CALL ME ISHMAEL

Music and Lyrics

to Melville's Moby-Dick

BY

PATRICK SHEA

CALL ME ISHMAEL ➢ *Patrick Shea*

www.callmeishmael.org

All songs ℗ and © 2008-2011 Patrick Shea

All parts written and performed by Patrick Shea, except:
Trumpet on "The Right Whale's Head--Contrasted View" by John Bryant
Fiddle on "The Quarter-Deck" by Molly Gia Foresta

All songs recorded by Patrick Shea in his bedroom

Art Direction and Design: Zachariah Mattheus

Illustrations: Lauren Kolesinskas

ISBN: 978-1-105-93268-7

CONTENTS

INTRODUCTION ... 5

VOLUME I ... 7

VOLUME II ... 31

VOLUME III .. 53

VOLUME IV .. 77

VOLUME V ... 99

VOLUME VI .. 119

VOLUME VII ... 139

VOLUME VIII .. 159

CALL ME ISHMAEL ➤ *Patrick Shea*

Introduction

In the summer of 2008, I set two goals for myself: to write a song every day for two months, and to read *Moby-Dick*. I had just finished my third year of teaching, and in those first intense years, I had let my musical life atrophy somewhat. I hadn't had a lot of time or energy to play, much less to write new songs. Adding to that, my bandmate at the time had just had his second child and was off the radar for a few months. I felt a little directionless, and I thought some specific goals would help.

My first goal had been long in the works. As any good songwriter knows, songwriting is a craft that requires regular exercise. I think George Harrison once complained of his lot in *The Beatles*, that John and Paul had already written their bad songs. I think George was saying that he couldn't expect to write songs as good as those written by John and Paul, when he was still relatively new to songwriting. In other words, talent or no, songwriting takes a lot of time and practice in order to be good at it. I thought that writing sixty songs in close succession would discipline my brain, and bring me back to thinking like a songwriter in the day to day.

My wife (then fiancé) and I took a trip to Mexico. I had been writing a song each day most often about random things, and feeling all the more directionless for it. I had brought along two books to read, both of which were long past due reads for me: *Ender's Game* and *Moby-Dick*. With the help of a couple of nights in the hotel with food poisoning, I blew through *Ender's Game*, and found myself opening to the table of contents of *Moby-Dick*. The chapter titles alone began to spark vocal melodies. So there I was, sick to my stomach in a Mexican hotel, singing into a dictaphone what would eventually become the chorus for "Fast Fish and Loose Fish."

That summer I wrote almost eighty songs about *Moby-Dick*, in addition to twenty or thirty more songs about topics ranging from politics to a laundromat in my neighborhood. The song-a-day task met with such fertile ground in *Moby-Dick* that I continued with it well into the school year, even with my wedding in the works. In August, I started recording some of the new songs. Over the next three years, I recorded a new song every Saturday morning with very few exceptions. I won't pretend that it was easy filling an already busy life with all this new work, but it also didn't feel hard—it was just something that I did naturally, because I needed to do it.

A lot of things surprised me about *Moby-Dick*. I was surprised by how funny it is. Some of the humor is pretty dark—Ahab's conversation with a severed whale's head in "The Sphynx," for example—but much of the humor is tender and affectionate—Ishmael's early encounters with Queequeg come to mind here. I was also surprised to find that *Moby-Dick* isn't really the story of Captain Ahab and his quest. If you ask someone what *Moby-Dick* is about, that's what they'll tell you. But if that's true, then *Moby-Dick* is a pretty poor, not very cohesive novel. I was pleased to find in *Moby-Dick* a lot more depth and complexity than the adventure story that I had expected.

Last but not least, I was surprised to find that every single chapter of *Moby-Dick* deserves a song. I thought that I would at least have to stretch myself to write for the two-paragraph chapters, but instead I found that no chapter left me at a loss for something interesting to think about. I haven't read many other books for which I can say the same, so I feel lucky to have found *Moby-Dick* at such a perfect moment in my life, and I feel lucky to have been able to spend so much time thinking inside its pages.

CALL ME ISHMAEL ➤ *Patrick Shea*

Volume I

CALL *ME* ISHMAEL

VOLUME I

CALL ME ISHMAEL ➤ *Patrick Shea*

CHAPTER 1
Loomings

Oh, the many morbid things
That the Fates obliquely sing
To the poets
Through a man come tumbling down.

You can call me Ishmael,
May the Muse speak through me well,
As I sing to you
The world's most principle song.

And were you
Lost in your deepest thoughts
Where need you be
But the ocean?
And so my story goes.

As a wounded Narcissus
The ocean gives to us
A reflection
An inflection of the deep.

And were you
Lost in your deepest thoughts
Where need you be
But the ocean?
And so my story goes.

And how
He
Looms in the middle of it all
Spectacularly.

CHAPTER 23
The Lee Shore

Your solemn eyes survive
As howled lullabies
By the hearthstone, in its comfort.
A ground to firmly stand.

There's nothing to it!
It's a safety dance.
When the weather's fair,
Do the Lee Shore!

But when the storm arrives,
Turn your keel to sea.
The immensity is your safest bet
To find a better way.

There's nothing to it!
Preconception's fine.
When the sky is bright,
Do the Lee Shore!

There's nothing to it!
When the tempest comes,
Let your soul roam free
From the Lee Shore!

There's nothing to it!
There's a higher truth.
If you break the chains
Of the Lee Shore!

CALL ME ISHMAEL ➤ *Patrick Shea*

CHAPTER 2
The Carpet-Bag

The universe is made,
And it's too late to make an improvement.
I shiver on the street;
I see all happiness from the outside.

Maybe I've been longing to come
From out of the darkness,
From out of the cold.
I've never had the money you got
To be on the inside,
To find me a home.

A pity we were made
With fragile bodies to be sheltered.
A pity that a man
Has to find a way to be sheltered.

Maybe I've been longing to come
From out of the darkness,
From out of the cold.
I've never had the money you got
To be on the inside,
To find me a home.

CHAPTER 4
The Counterpane

Now he's hugging me,
Oh, so lovingly;
I woke up in Queequeg's embrace!
Like a brother, pagan other
In my bed.

It reminds me of when I was but a child,
I once fell asleep
And woke with a phantom's limb
Hand in hand with me.

He's considerate,
Though not literate—
Politeness must be innate,
Like a patchwork of decorum
And disgrace.

And for all of my high civil breeding
I have to admit,
I stared on quite rudely
Through Queequeg's strange toilet.

So he shaves his face
With a harpoon blade—
A savagely civilized art!
He's a darkness, with a
Civilizing heart.

CHAPTER 3
The Spouter-Inn

There's a painting in the tavern, obscured,
As a token for the rest of the world.
In the soot and in the grime,
In the ravages of passing time,
Stand we still, constructing a purpose.

Of the masses, of the shadows and shades,
In the chaos, in the purposes made—
In the center a parody,
Though in full sublimity,
All transfixed by a failure of meaning.

And so is man
A shrouded reason,
Lost in the
Majestic reaches
Of his share of total unknowing.

There's a stranger in the tavern with me,
Stands as other, contrasted naturally.
In a moment I understand,
At the center this fellow man
Shares my darkness, and we can sleep easy.

And so is man
A shrouded reason,
Lost in the
Majestic reaches
Of his share of total unknowing.

CHAPTER 74
The Sperm Whale's Head—Contrasted View

A one track mind,
Baby's got a one track mind.
A killer's eyes,
Keep 'em on a narrow line.

A purposeful mind
Because a purposeful physiology.
The eyes define
The front of a man, don't you see?

You're always right,
Never seeing side to side.
You got big eyes,
Still you never see both sides.

Enlarging your mind
But what you really need is subtlety,
Conflating a dual view
To consciousness.

Don't you realize
Your half-blind maliciousness?
Monomania:
It's arithmetic.

CALL ME ISHMAEL ➤ *Patrick Shea*

CHAPTER 10
A Bosom Friend

My Christian concern for you
Has melted, noble savage.
In you I see the world that Christ desired.

A wolfish, hollow courtesy;
My ship has run aground
On the shallow, rocky shelf of Heaven's shores.

God bless your savage heart,
Without corruption, malediction,
Or the grand deceits that split our brotherhood.

To join your idolatry,
In faithful unity,
Should make God happier than sweeping you aside.

Here I am,
Half a Judas,
A bosom friend.

CHAPTER 89
Fast-Fish and Loose-Fish

Fast-Fish and Loose-Fish,
Anything that's free is yours to want!
Fast-Fish and Loose-Fish—
A person, place, or thing, it doesn't matter.

It isn't small coincidence:
Possession is the full of the law.
Who can stop the powerful
From taking some or taking it all?
Wait and see!

Fast-Chicks and Loose-Chicks,
You cut your woman free, she's there to take!
Fast-Chicks and Loose-Chicks,
Harpoon that little lady and ride her wake!

And what is Southern slavery?
Possession is the full of the law!
And what's a thieving archbishop?
Power is the rule of the law!
You can see!

But how was America a Loose-Fish
In the time of Columbus?
When Russia took Poland,
Or the Turk took Greece?
And what are the rights of man but a Loose-Fish?
(There for the taking!)
But not land for Duke of Dunder's oldest son.
(The law's for the victors!
The law's for the victors!)

Fast-Fish and Loose-Fish
Anything at all is theirs to want.
Fast-Fish and Loose-Fish—
A person, place, or thing, it's so convenient!

CALL ME ISHMAEL ≻ *Patrick Shea*

CHAPTER 44
The Chart

Reshape the tides and eddies,
Harpoon standing at the ready.

A single intent and purpose,
A point of such gravity,
Bends light, and so perception—
The real world is just perception.

So I'll say what I say,
And you do what you do,
'Cause I've charted the patterns of me and you,
And it's going to come back to a point of truth.

I dreamed the very moment,
A point of such gravity.

So I'll say what I say,
And you do what you do,
'Cause I've charted the patterns of me and you,
And it's going to come back to a point of truth.

CHAPTER 110
Queequeg in his Coffin

Make your peace with death,
Your peace with death,
Your peace with death, Oh
Your peace with death,
And then come alive
For the rest of your days.

Listen to me, now:
I want to tell you 'bout a man
Who came to his endless end, Whoa!
He threw his arms around the great
Testament.
He had us build a coffin,
Sound in every way,
And he stepped into the rest of his days.

Make your peace with death,
Your peace with death,
Your peace with death, Oh
Your peace with death,
And then come alive
For the rest of your days.

Let me tell you, now:
The man he had his coffin filled
With all of his earthly needs, Whoa!,
And put his body with the like
Accessories.
He took his god, Yojo,
And held him to his heart,
And he rose again, a purity apart.

Make your peace with death,
Your peace with death,
Your peace with death, Oh
Your peace with death,
And then come alive
For the rest of your days.

CALL ME ISHMAEL ➤ *Patrick Shea*

CHAPTER 16
The Ship

Yojo sent me to find a ship!
Yojo sent me to find a ship!

Oh, Yojo, did you send me to the Pequod?
Oh, Yojo, did you send me to Ahab?

Nothing could seem more wise
Than the wrinkles 'round Pelig's eyes.

Oh, Pelig, won't you tell me what whaling is?
Oh, Pelig, it's a right ferocious accident!

To see the world from a whaler
Is just lookin' at water, sailor.

And he despises those merchant ships!
And he disguises old Ahab's tics.

We'll sign you on, young fellow,
But first give our other owner a hello.

How could a Quaker kill a whale?
Bildad? Captain Bildad, can't you say?
You read the scriptures every day!
How far ye got?

So sign on for a 300th lay my son (you're a lucky one!),
And bring your mysterious harpooner friend along (he's a-welcome on!).
The Pequod will be your final home.
The Pequod will take you to your home.

CHAPTER 132
The Symphony

Remember.
Remember.
Remember when I was a boy?
I was a boy.
I was a boy.
I was a boy when I first killed a whale.

For forty…
For forty…
For forty years I fought the…
I fought the…
I fought the…
I fought the dark portentous…

Here's a motion,
A decision
Of devotion.
It's a choice,
But here am I blind:
How do I know it's mine?

And now I…
And now I…
And now I weep into the sea.
The sea has…
The sea has…
The sea has finally felt the soul of me.

Who makes the…
Who makes the…
Who makes the hunter kill the lamb?
The lamb is…
The lamb is…
The lamb is never peaceful but apprised.

Here's a motion,
A decision
Of devotion.
It's a choice,

CALL ME ISHMAEL ➤ *Patrick Shea*

But here am I blind:
How do I know it's mine?

I was a boy.
I was a boy.
I was a boy when I first killed a whale.

Volume I

CHAPTER 33
The Specksynder

The bigger the pomp, the lesser the leader—
Compensatory trappings, you know?
An officer's supremacy
Is idiot supremacy, whoa!

The harpooneer gets to sleep by the captain,
But he's not called an officer, no!
He's just set apart
So the men will heed his art.

On a whaling ship, there's a shared interest—
You see, we're all working,
And there is no rank
'Til a whale is on the planks
'Cause men are men alike in reason.

Oh, oh Ahab, you're the truth,
'Cause you never play the emperor
But you still stand apart.
What shall be
Grand in thee
Must needs be plucked at
From the skies, and dived for in the deep!

CALL ME ISHMAEL ➤ *Patrick Shea*

CHAPTER 18
His Mark

Harpoon the mast,
And sign those papers fast!
Old Peleg's sharp—
Had Quohog make his mark.

Signed a charm
That was tattooed on his arm
And now he's with the crew,
Despite that devil's blue.

Young cannibal,
Your hell awaits in full.
Avast ye, man!
A harpooneer's not a man

To be saved
Laying whales in their graves—
Give to darkness now,
Standing in the prow.

You could never do it so well,
Knowing Jesus sees it.

Religion's fine,
And death will come in time,
But pious men,
They lose the shark in them.

Made His mark
In the everlasting dark
Found in every man
With harpoon in hand.

You could never do it so well,
Knowing Jesus sees it.

Volume I

CHAPTER 73
*Stubb and Flask kill a Right Whale;
and Then Have a Talk over Him*

Shadows long to the starboard side,
Are we charmed to perdition?
And ain't the devil proof
Of deeper meaning?

See the weight of commerce pull,
Balanced only by murder.
And see the balance
Threaten to whelm us.

There's a storied governor
Made a deal with the devil,
So one's infected now
And all will perish.

Blessed by the inspiration
Of holy-rolling,
We're doomed to watch the nation
Go down, down, down.

CALL ME ISHMAEL > *Patrick Shea*

CHAPTER 85
The Fountain

Oh, Believer or Infidel?
Oh, Believer or Infidel?

Not for a want of science—
Oh, perception isn't half enough!
And not for a want of prophets—
Oh, mysticism's imprecise!

Oh, will we ever understand
The mysteries of nature's hand?

We can't tell the difference—
Is it water or is it air?
The spout is of significance
As an observable phenomenon.

Yeah, these creatures of the deep
Are filled with the profundity
Of the Heavens and the Earth,
Whoa, whoa!

So you can't get very close,
To study or experiment—
It once burned a man to the quick!
Whoa, whoa!

Oh, was it hubris that struck him down,
Or unfathomable nature, now?
Oh, Believer or Infidel?
Oh, Believer or Infidel?
Regard them with an equal eye!

CHAPTER 112
The Blacksmith

Find me the mercy of evasion,
My only testament taken
Upon the desolate sea,
The only merciful.

Beat with a stoical compassion:
I'll bring my hammer to you,
I'll bring my hammer to you.

Launch from everything tried;
Cast the living world aside.
It's a fully sheltered lee,
But how could you?

Ode to the infinite and drifting—
By possibility lured.

'Cause it happened.
Oh, 'cause it happened,
My hammer patiently beats.

CALL ME ISHMAEL ➢ *Patrick Shea*

CHAPTER 96
The Try-Works

The sun shows the ocean,
A two-thirds of darkness.
And what more to man than that he realize
His two-thirds of darkness just the same?

Turn from the fire
With hand on the helm.
Tomorrow the sun will light those demons,
And show the honest face of man.

Truth in your sorrows
When lit from your mirth.
As eagles would fly into canyons
And live to soar above the peaks,
The canyons do soar above the lowlands
And birds who shun their majesty.

CHAPTER 37
Sunset

Bask gently
In the melody,
Oh sailors
Of the sea!

The Almighty
God above
Knows just
What you'll be.

Good sailors,
Come with me.
We'll bring Him
To His knees.

God brings us down,
Leaving with one final stroke
Upon the everyday crown
Of the man he made, certain
To be everything.

Take pleasure
In the melody,
Oh heavens
Of the deep!

You struck me,
But I come again,
Now bearing
My teeth.

You bring us down
And then you hide in the smoke
Above the factory ground.
You lose yourself if you ever lose me!
If you ever lose me!

CALL ME ISHMAEL ➤ *Patrick Shea*

Afterword to Volume I

Who knew that a grimy painting on the wall of an inn could provide such fertile ground to discuss the metaphysics of subject and object, of self and other, and of the narrative nature of consciousness? Who knew that marking a killed whale with a flag could be so emblematic of much larger world issues surrounding property, human rights, and colonialism? One of the most compelling aspects of *Moby-Dick* is Ishmael's ability to magnify minutiae into abstractions of greater philosophical significance, and in so doing to string together a series of unrelated details into a complex and entertaining story. Ishmael would have made a good songwriter.

An important part of the song-a-day challenge for me is to ask myself the question, "What do I think beyond the obvious things that I think?" If I write seven songs one week about the seven things most on my mind at this point in my life, what's left to write about? I often find that those obvious thoughts are obvious because they appear to me in pretty broad strokes, and that forcing myself to write past those ideas also forces me to think in more detail, to take ideas in smaller chunks and to examine those smaller chunks for greater significance. Maybe that means I stop thinking about New York City, and think instead about the bodega on my corner, or the broken phone booth by the bodega, or one of the stickers on the broken phone booth. Maybe it means spending a morning thinking about just one chapter of a book, or even a couple of paragraphs from that chapter. The world and the book each become a different kind of thing in the context of that sort of magnification.

Something serendipitous happened in choosing to write songs about individual chapters of *Moby-Dick*. I found myself magnifying Ishmael's magnifications, abstracting his abstractions. *Moby-Dick* became something incredibly personal in the process. For example, "The Carpet-Bag," follows a pretty simple, though lengthy plot—Ishmael wanders around New Bedford looking for a place to sleep. He stumbles into a black church, he turns himself away from an expensive-looking inn, and then he finds the Spouter-Inn, where he decides to stay. However, before all is said and done, Ishmael muses about the vast difference in experiencing a cold wind from inside a warm house, and experiencing a cold wind from inside a cold house. He further abstracts to thinking about this house as one's body, and the difference in experiencing hardship depending on one's inner state of being. He thinks about a rich man named Dives, who lives in a luxuriously warm house, but lives there all alone, making his life all the more cold and death-like, despite his luxury. Ishmael, too, finds himself alone in the world, but decides, "it's too late to make any improvements now. The universe is finished; the copestone is on, and the chips were carted off a million years ago." In these lines, Ishmael is plainly talking about the human body being unsuited for cold weather, but in these lines I also see an extraordinary conflict in Ishmael, perhaps even the primary conflict in *Moby-Dick*. Ishmael compares a congress of the marginalized in the black church, with a lonely man of power and luxury, and sees the worst of his lot in each. But it's hard to change such fundamental qualities of one's personality, and I sense some resigned, half-despairing pause in Ishmael's final decision to enter the Spouter-Inn, and so attempt to come in from the cold, both literally and figuratively.

I've read "The Spouter-Inn" several times since writing my song about it, and each time I am pleasantly surprised to find other whole sections of the chapter, other songs that someone could write by focusing on other aspects of Ishmael's thoughts and experiences. For instance, another songwriter might be taken with Ishmael's determination to ship from "her great original" whaling port of Nantucket. Or perhaps there's an economic critique to sing about the utter darkness enveloping this new commercial giant of New Bedford, and the preacher's sermon on "the blackness of darkness, and the weeping and wailing and teeth-gnashing there." I often forget that these pieces of the chapter even exist, because my strongest personal connection with the chapter happened in a different set of sentences as I wrote my song. In writing my song, I think I narrowed my focus to the most important core idea of the chapter, but maybe I actually narrowed my focus to the most important core idea of myself. Here at the end of writing these songs, I'm not sure that there's any difference between the two. I see as much of myself in every song as I see of *Moby-Dick*, and that's as it should be.

CALL ME ISHMAEL ➢ *Patrick Shea*

CALL ME ISHMAEL

VOLUME II

CALL ME ISHMAEL ≻ *Patrick Shea*

CHAPTER 97
The Lamp

I'm bathed in the light,
I shine in the purity—
A tailor of right,
Equal luminosity.

And the vessels of light are the common vials
Of the everyday man
Emptied of their recipe,
Retooled to help us see.

I live at the roots,
The primal dichotomy—
A fork in the road,
A choice in its infancy.

And I'm filling our lamps with the murdered beasts.
Only nature can lead
From the fool's eternity,
Untainted by human beings.

Sleep in the light as if I'm only
Closing my eyes for a while.

I'm bathed in the light,
I shine in the purity—
A tailor of right,
Equal luminosity.

And the vessels of light are the common vials
Of the everyday man
Emptied of their recipe,
Retooled to help us see.

And the vessels of light are the common vials,
And the vessels of light are the common vials,
And the vessels of light are the common vials
Of the everyday man,
To help us see.

CHAPTER 32
Cetology

You decide,
And science will accommodate!
You decide,
And science will allow
For your base impressions
To rule their calculated epiphanies—
Spread it on the breeze,
And deep into the seas.

We're the same inside,
But you can't oppress a man,
So they must
Be of beast—
Well they live like beasts.

You decide!
For your base impressions
To rule their calculated epiphanies—
Spread it on the breeze,
And deep into the seas.

Let the science ride;
Be as simple as you can!
Darker skin: different race,
Harder work, submissive face.
Speak eugenically!

You decide,
And science will accommodate!
You decide,
And science will allow
For your base impressions
To rule their calculated epiphanies.
Spread it on the breeze,
And deep into the seas.

CALL ME ISHMAEL ➤ *Patrick Shea*

CHAPTER 95
The Cassock

Drag me up from the depths
Of your wandering soul,
Let me light your fire,
Baby, you know!

Chain me up to the side
Of a perishing race
Of resistance,
Baby, you know!

It's a long time coming now!
It's a long time coming now!

Take the blackest flesh
As a garment to wear
For the portioning
Of spiritual wealth.

Slice it thin, father,
Thin as a Bible leaf
'Til it breaks you,
Baby, you know!

It's a long time coming now!
It's a long time coming now!

Isn't God defined
As a total control,
So if you fought and won
His power for all

It would still be a choice
That your God had made
And you'd still be
A subject enslaved?

It's a long time coming now!
It's a long time coming now!

CHAPTER 17
The Ramadan

No suicides here,
And no smoking in the parlor, dear.
He's locked himself inside—
I'm shut out 'til the rising tide.

The keyhole affords
No better view than half the floor—
He's nowhere to be seen
Beyond his weapon in the corner leaning.

Queequeg prays (sit alone in the cold for your Ramadan
With Yojo on your head) to the God who gives him voice;
It's the choice of every man.

Queequeg prays (sit alone in the cold for your Ramadan
With Yojo on your head); oh, who am I to say
That my Christian faith's the only way.

I burst into the room—
Shuttered like a bud to bloom,
My best friend remains
In the piety of pagan names.

I tell him when he wakes,
That religion needn't cause him pain.
He smiles back at me,
In friendship, never condescension.

Queequeg prays (sit alone in the cold for your Ramadan
With Yojo on your head) to the God who gives him voice;
It's the choice of every man.

Queequeg prays (sit alone in the cold for your Ramadan
With Yojo on your head); oh, who am I to say
That my Christian faith's the only way.

Queequeg prays.

CALL ME ISHMAEL ➤ *Patrick Shea*

CHAPTER 75
The Right Whale's Head—Contrasted View

We're all in the whale's mouth,
Swallowed whole by a sullen pout—
The king of the ocean,
With Stoic emotion.

Hey! Look at all the oil we got!
Hey, hey, hey! The tongue and lip and blanket's off!
And ladies, hey ladies!, here's a little savagery for you—
Not a little savagery.

Step in this mouth,
It's twelve feet tall. (Oh, no, no, twelve feet tall!)
Pipe organ bones,
So worshipful. (Oh, oh, oh worshipful.)
It's the teepee of an Indian;
I swear I'll never sin again!

Hey! Look at all the oil we got!
Hey, hey, hey! Order in the sea's chaos!
And ladies, hey ladies!, here's a little savagery for you—
Oppressive little savagery!
And ladies, hey ladies!, here's a little savagery for you—
Not a little savagery.

It's the teepee of an Indian;
I swear I'll never sin again!

Hey! Look at all the oil we got!
Hey, hey, hey! Order in the sea's chaos!
And ladies, hey ladies!, here's a little savagery for you—
Oppressive little savagery!
And ladies, hey ladies!, here's a little savagery for you—
Not a little savagery.

Volume II

CHAPTER 57
Of Whales in Paint; in Teeth; in Wood; in Sheet-Iron; in Stone; in Mountains; in Stars

Crush uncrushable seas beneath a tempest's tail.
Spur impetuously into the primal.
Right or wrong, the trained of form will miss you.
God alone can carve you

Into the mountainous,
Celestial countenance,
Into the stones and bones
And token homes of sailors' souls.

Fight the kraken where the bastion overflows,
And no striation could subsume the war machine.
Weak or strong, a man could never tame you.
May God impress your savage form

Into the mountainous,
Celestial countenance,
Into the stones and bones
And token homes of sailors' souls.

Weak or strong, a man could never tame you.
May God impress your savage form

Into the mountainous,
Celestial countenance,
Into the stones and bones
And token homes of sailors' souls.

CALL ME ISHMAEL ➤ *Patrick Shea*

CHAPTER 5
Breakfast

You've travelled the world and the eastern seas,
You've travelled the world.
You're made of the great human melodies
From all over the world.

And you'd think it's a matter of deepest sympathy
To be out in the world,
But then you run, run,
From the great menagerie—
You haven't a word!

You've sailed in time to the harshest breeze,
All over the world.
You've never been graced with a luxury,
And never preferred.
But then you run, run,
From the great menagerie—
You haven't a word!

And you'd think it's a matter of deepest sympathy
To be out in the world,
But you're turning
Inward, baby, take your time—
You're out in the world!

CHAPTER 36
The Quarter-Deck

All visible things
Are but a sculpted mask
Held before the visage
Of some unspeakable truth,
Nothing known but for our suffering.

I'll strike at the mask,
Never mind it agent
Or principal.

And I'd fight the sun
If it aimed at any pride
In all my earthly bounty;
Scattering, every ember shared
For eternity.

The knots in my mind
Tighten 'round a critical
Density,
And furrow into my brow
With an irresistible gravity.

Now pass the cup
And we'll ration out
The victory.

And I'd fight the sun
If it aimed at any pride
In all my earthly bounty;
Scattering, every ember shared
For eternity.

CALL ME ISHMAEL ➤ *Patrick Shea*

CHAPTER 119
The Candles

Lay out your vestments
On the altar, and pour libations (Hear us sing our spirits high!).
Burn us in perdition
As an offering for your salvation (Sha na na na na na na!).

Standing on the back of
The devil himself.
I'll shout you off the mountain,
No matter the feat.
You made me from the fire
And I'll bring it to you!

So you're the light that sprung from
An utter darkness (you'll never know what made you be).
Well I'm the darkness sprung from
Your utter lightness (Sha na na na na na na!).

You're everywhere at once.
You're never with me.
Strength is in the human
Personality.
We made into a person
An impersonal being.

Here's to the oath, mighty ruin!
We've taken an oath, never truant!
The hour is nigh, come alive!
Come alive!

Lay out your vestments
On the altar, and pour libations (Hear us sing our spirits high!).

CHAPTER 87
The Grand Armada

The center of the tempest,
A situated bastion, a nursery.
It's an internal escape
From the great colonial rape,
Cunning and relentless.

A league of opposition,
The grand armada, frightened and meek,
As a herd of buffalo,
From a horseman charged alone,
Scatters into ashes.

So piracy—
We're rising up
Between the spaces
Of formality,

And, lo,
We're coming to
Our own conclusions…
Death before hegemony!

The murder of cohesion,
Confusion in the waters, a panicking.
Resist the very sun,
That never needs to rest—
They'll get you while you're breathing.

Resist the very sun,
That never needs to rest—
They'll get you while you're breathing.

CALL ME ISHMAEL ➢ *Patrick Shea*

CHAPTER 113
The Forge

Pierce my heart!
Lift the lonely curse of mystery.
Hold me fast,
And forgive the choice we never had.

I've heard the hollow ring of ivory on the deck;
I've felt the final sting of needles and pins.

Smooth your brow!
Beat the creases into destiny.
Forge your steel,
Temper all intent in liberty.

I've heard the hollow ring of ivory on the deck;
I've felt the final sting of needles and pins.

Tell me, blacksmith,
Do you live in the devil's heat
Without a singe?
Do you sharpen the killer's beak
Without a singe?

Pierce my heart!
But I'll break the bond between us.
Fighters fight—
Oh, you know it's only the natural order.

I've heard the hollow ring of ivory on the deck;
I've felt the final sting of needles and pins.

Volume II

CHAPTER 117
The Whale Watch

Haven't you read Macbeth, old man?
Though the prophecy promised you'll never die,
It's gonna be bad.

'Til Burnham Wood comes to Dunsinane,
And nothing but hemp can kill you—
Ahab, you're fucking insane.

You hear what you want
Whenever you want it.
You do what you should
Whenever you choose.

Everybody heard Fedallah say:
You're gonna die, you're gonna die.
And Fedallah knows what he's telling you:
You're gonna die, you're gonna die.

Neither coffin nor hearse can be thine—
It's a civilized comfort to be buried inside
That your nature denied.

We can't even call it irony—
He told you that you'll die when the Pequod sinks,
And he said it plainly.

You hear what you want
Whenever you want it.
You do what you should
Whenever you choose.

Everybody heard Fedallah say:
You're gonna die, you're gonna die.
And Fedallah knows what he's telling you:
You're gonna die, you're gonna die.

Haven't you read Macbeth, old man?
Though the prophecy promised you'll never die,
It's gonna be bad.

CALL ME ISHMAEL ➤ *Patrick Shea*

CHAPTER 29
Enter Ahab; to him, Stubb

Summer nights
I've been sailing on the oceans of memory,
A vision I've been saving of you.
Following you
In a passion, my actions are a remedy
For the truth.

Summer nights
I've been pacing, cracked upon your every dream;
Sleep feels like I'll slumber indefinitely.
Up from my tomb
In a restless, ponderous oppressiveness
Over you.

The days are overflowing with peacefulness,
The warmth of but a passing goodbye.
I stand upon the only
Leg you left to hold me
Upright in the great ecstasy!

Summer nights
All I want is another dance for you and me,
A chance to make you forever mine.
Longing for you
Is a purpose, an absolute subversiveness
Of the rules.

CHAPTER 56
*Of the Less Erroneous Pictures of Whales,
and the True Pictures of Whaling Scenes*

Poetry in motion!
Poetry in motion!
So chop away
At their flanks, come on!

Poetry in motion!
Poetry in motion!
The war identity
Captured in every painting,
Good and true.

You'll never have a picture
Without the reckoning force,
The justice of the scriptures,
Of nature's course!

Humans live in the action!
Humans live in the action!
Construct a narrative
Through adversaries, oh!

Humans live in the action!
Humans live in the action!
Emotions conquering
Our studied observations
For the truth.

You'll never have a picture
Without the reckoning force,
The justice of the scriptures,
Of nature's course!

Poetry in motion!
Poetry in motion!
So chop away
At their flanks, come on!

CALL ME ISHMAEL ➤ *Patrick Shea*

Poetry in motion!
Poetry in motion!
The war identity
Captured in every painting,
Good and true.

CHAPTER 93
The Castaway

As my body's buoyed
So my soul does sink—
Beheld the primal device!

In the open ocean,
I'm the center stage—
Like the sun, castaway.

And I never knew
What a concentrated
Mass of self rests in me always.

Do I seem a little crazy?
Heaven never speaks with reason,
And I could never surmise
How to speak with reason.

I'm frail in body,
But I've held the weight
Of God on my undisguised soul!

And I'm here before you
As a Titan stands—
Terrorize all rationality.

Do I seem a little crazy?
Heaven never speaks with reason,
And I could never surmise
How to speak with reason.

CALL ME ISHMAEL ➤ *Patrick Shea*

CHAPTER 130
The Hat

Intents and purposes are clear—
Hoist you up into the stratosphere.
A sycophantic sort of sight—
The greater vantage offered less, perspective-wise.

You cast a shadow on the deck,
It's staring out into the infinite,
And though you're perched above a mirror,
You'll never see your own reflection any clearer.

Depended on your opposition
To leverage you into a god's position,
And then protect you in your nest,
A cunning ruler to enfranchise your enemies.

A bird of omen!
A bird of omen!
A bird of the seas!

A bird of omen!
A bird of omen!

Took the curtains off the windows of the castle of your soul,
The obsfucation of the dark below,
And flew into the current of time,
And dropped your crown
Into the fertile ground
Anew!

CHAPTER 38
Dusk

Starbuck:
He's a democrat to all above,
Taking power for everyone,
But in the end he's a tyrant to his brothers,
Hand in hand.

He hypnotized my reasoning,
Stripped me as a human being,
As if I was taken by a demon,
Faltering.

Chorus:
We are the crew of Captain Ahab!
We're going to rule the sea!
We are the crew of Captain Ahab,
We are free!

Starbuck:
We're going to
Hell! See the revelry!
Hell! Dragging us to sea!
Hell! And the darkness left of life.

His torment strangely did compel
An oath be taken to rebel.
Throw off your chains for yet another
Kind of yoke!

Chorus:
We are the crew of Captain Ahab!
Nursed among the sharks!
We are the crew of Captain Ahab,
Men apart!

Starbuck and [Chorus]:
We're going to
Hell! [We are the crew! We are the crew!]
Hell! [We are the crew! We are the crew!]
Hell! [We are the crew! We are the crew!]
[We are free!]

CALL ME ISHMAEL ➤ *Patrick Shea*

CHAPTER 21
Going Aboard

The tongues of an ebbing tide
Lapping against the boat,
And the light of the coming dawn glowing far and wide.

The silence that stills a heart,
And the fog that begins to lift
With the shadows that stow away under the boards.

We're the undertakers of the coming tragedy!
Turning our backs, the prophet makes us family.

We're the undertakers of the coming tragedy!
Fatten us up for footstools, come the coming feat.

Warnings upon the breeze,
As it teases against the sails
As a portent of future speed bracing the yard.

Nowhere a soul to stir.
The cabin is locked up tight.
Smoking with sleeping rigors deep in the bow.

We're the undertakers of the coming tragedy!
Turning our backs, the prophet makes us family.

We're the undertakers of the coming tragedy!
Fatten us up for footstools, come the coming feat.

Volume II

Afterword to Volume II

Music has many elements that a songwriter uses to communicate a given idea. Traditionally, these elements include things like rhythm, melody, cadence, or harmony. For me, working with pop music opens up a less traditional but no less powerful musical element with which to communicate—that of genre itself. Choosing to write and arrange a song as dark psychedelia, and choosing to write and arrange a song as protestant hymn would communicate very different things about any given chapter, for two reasons. First, different genres live in very different sets of moods and tones—find me an Episcopal hymn that makes you want to dance—and second, any given genre carries a wide and deep array of both individual and social associations and connotations that bring a whole set of ideas to bear on any given chapter by the choice of genre alone.

Sometimes genre can contribute to a song in a fairly direct way. The chapter "Of Whales in Paint; in Teeth; in Wood; in Sheet Iron; in Stone; in Mountains; in Stars" talks about the raw brutality and natural power of a whale being most truly captured in raw and powerful natural forms, such as being hewn into a mountain by the forces of nature itself. I don't know if I could have passed this chapter up as an opportunity to write a metal song, and still looked at myself in the mirror every morning.

Sometimes genre can become commentary by contrast. In "The Right Whale's Head—Contrasted View," Ishmael deconstructs a right whale's head, cataloguing piece by piece each commodity to be sold. There's something very cold and matter-of-fact about the process that reminded me of Kurtz extracting ivory from Africa in *Heart of Darkness*. There's a calculated force of civilization at work, imposing order on the natural world by destroying it and turning it into something saleable. I thought that writing this chapter's song as a carefree show tune would, by contrast, add to the underlying menace of this kind of commercialism.

Either way, the choice of genre makes a big difference in what the song says about a chapter. When writing "The Lamp," a chapter about whalemen sleeping with their lamps (luxuriously) lit, I latched onto the line, "...the whaleman, as he seeks the food of light, so he lives in light." To me, that idea implied whaling as a religious pursuit, and so my mind jumped to a choral gospel song with the recurring line "I'm bathed in the light!" But I quickly realized that "The Lamp" is part of a mini-cycle on labor, and that the "food of light" is labor itself—the very American ideal that honest labor ennobles us, and brings us into the light of self-actualization. A gospel song would miss that point entirely, so I thought instead to industrial towns, and settled on the somewhat R&B/gospel tinged post-punk working class anthems of Manchester in the late '70's and early '80's. Somehow, it felt right to me, even though it's *British*.

Moby-Dick lends itself particularly well to multi-genre work like this because the story itself is something of a multi-genre piece. The most obvious example to me is the minstrel show of "Stubb's Supper," as Stubb torments the black cook and the cook responds with an aggressive exaggeration of the submission that Stubb demands of him. There's also the theatrically staged "Midnight, Forecastle," the tall tale of Steelkilt in "The Town-Ho's Story," the Shakespearian "Whale Watch," and so on. In Moby-Dick, Melville played with

CALL ME ISHMAEL ➤ *Patrick Shea*

literary genre and the associations they brought to bear on his story, so I thought that taking a similar approach with my songs would be appropriate, if not necessary in capturing the spirit of the book.

Multi-genre projects can be difficult to take in for the same reason that I find them interesting and fruitful—any given volume of *Call Me Ishmael* will push you and pull you through many different moods and tones. Most of the time, people choose a particular record for its ability to contribute a soundtrack to the now—something calming while I eat dinner, or something upbeat while I clean the bathroom. One of the things that I miss in my adult life is the almost limitless time of my youth to sit in front of the stereo and just listen to music, and I like that this project asks that of me.

CALL ME ISHMAEL

VOLUME III

CALL ME ISHMAEL ➤ *Patrick Shea*

CHAPTER 13
Wheelbarrow

Packing my bags with my best friend.
Walk down the street with my best friend.
People will stare at us always,
Sharing the load!

Don't be embarrassed,
Because we cherish
Mutuality.

Stare at the sea with my best friend.
Happy to be with my best friend.
Closing the gap there between us,
Building the road!

Don't be embarrassed.
Platonic marriage.
The world's a joint-stock company!
We help each other be.

People may laugh at my best friend,
Stab at the back of my best friend,
He never holds it against them;
He'll always help his fellows!

Don't be embarrassed.
Platonic marriage.
The world's a joint-stock company!
We help each other be!

CHAPTER 53
The Gam

Whaling ships are having a good time
Roaming on the open sea!
Pirate ships are villainous rascals,
Locked in their castles
With no "good day" to me.

Merchant ships are spurious dandies,
Brushing off their brethren without a heed.
Slaving ships are running from something,
And ceremony mars
The meeting men of war.

On the open sea,
Lend the courtesy,
As the whalers do with every passing of keels.
Oh, let's have a gam,
I'll extend my hand
To all sailors who share the jaunty rhythms of the sea.

Passing correspondence between us,
Pluck upon my tethers to home.
Tell us where the whales run the thickest,
Wherefore the riches
Surface from the foam.

On the open sea,
Lend the courtesy,
As the whalers do with every passing of keels.
Oh, let's have a gam,
I'll extend my hand
To all sailors who share the jaunty rhythms of the sea.

Whaling ships are having a good time
Roaming on the open sea!
Join us for a bit of a ramble,
And let the ocean handle
The grave philosophies.

CALL ME ISHMAEL > *Patrick Shea*

On the open sea,
Lend the courtesy,
As the whalers do with every passing of keels.
Oh, let's have a gam,
I'll extend my hand
To all sailors who share the jaunty rhythms of the sea.

CHAPTER 58
Brit

The ocean's deeper than us,
No man protected from washing away.
Oh, scratch the surface but once
With a bold keel, and you will be changed.

And we all fall down,
All fall down,
In the two-toned world we create.
Yeah we all fall down,
Strangers in lonesome parade.

We look from surface to sky,
A truncated wave to rise and abate.
Count yet magnificent worlds,
A negative voltage constantly craved.

And we all fall down,
All fall down,
In the two-toned world we create.
Yeah we all fall down,
Strangers in lonesome parade.

Yeah we all fall down,
Strangers in lonesome parade!

CALL ME ISHMAEL ➤ *Patrick Shea*

CHAPTER 88
Schools and Schoolmasters

A man in need is lonely indeed
'Cause his friends don't ever stick around,
But girlfriends know, when trouble's at the door
You should never leave a good friend!
You should never leave a good friend!

Men will fight each other for the right
To defend a woman 'til the end.
They'll party right through each and every night
'Til a woman comes between them!
'Til a woman comes between them!

Oh, girls last forever!
Together 'til the end!
Girls last forever!
Everlasting friends!

Men like making babies in the night,
but they never want to nurse them.
They leave their girls alone to brush the curls—
Thank heavens for a girlfriend!
Thank heavens for a girlfriend!

Oh, girls last forever!
Together 'til the end!
Girls last forever!
Everlasting friends!

CHAPTER 63
The Crotch

Not foreshadowing,
I take my time with the details still,
To set the stage.

No complaining!
You need to live every moment of
A whaler's life.

Let's not sully
The great defiance
In every action
With mere description!

Let's prepare you
To construct
The moments as they come,
And I will step aside.

Now imagine
Two harpoons on a single line,
And tossed at sea.

The whale is struggling,
The loose harpoon flaps from side to side
With sharpened steel.

Now imagine
Every boat on a single whale
With loose harpoons.

You're gonna use it.
The image sifts back into your mind
Until the end.

Let's not sully
The great defiance
In every action
With mere description!

CALL ME ISHMAEL ➤ *Patrick Shea*

Let's prepare you
To construct
The moments as they come,
And I will step aside.

It's not the way
You're used to reading—
I'm aware of it.
Now let me step aside!

CHAPTER 41
Moby Dick

Let's talk of the depths!
We're of the cavernous Earth—
We take in the rocky chasms
At the very moment of birth.

Under the heart
(In all a darkness),
An ancient and fragile king
As pillar, quivering.

As a whale under the ocean, no one knows
All to bear from private spaces.

Now spin me a yarn,
No simple matter of fact.
In facing the grandiose
We take a supernatural tact.

So as within,
Deep down below
An ancient and fragile king
As pillar, quivering.

As a whale under the ocean, no one knows
All to bear from private spaces.

In all the world
There is a weight of defeat
Breaching the placid surface
With an ubiquity.

So grand, indeed,
Call it the devil and plead,
Or muster the soul's harpoon
From madness.

CALL ME ISHMAEL ➤ *Patrick Shea*

CHAPTER 102
A Bower in the Arsacides

Turn, and turn, and turn,
The body's a temple!
Turn, and turn, and turn,
The body's a temple!

Everybody go to an island in the Arsacides!
In a hilltop glen, find the secrets of a function,
Long layered as the base,
Foundation of every dead and living race.
It's all in the body,
The memory of body.

Turn, and turn, and turn,
The body's a temple!
Turn, and turn, and turn,
The body's a temple!

Every man a life woven through the spaces of every death.
Frames of passage carved with a long-learned certainty.
A pean to the shoulders
We grow on, but not over.
A density, breathing.
Oh, oh.

How to measure life? Turn into the body,
Measure every rib, measure every quarry.
Every bit is made from a something made before.

CHAPTER 34
The Cabin-Table

Dinner, Mr. Starbuck.
Dinner, Mr. Stubb.
Dinner, Mr. Flask.
Yeah!

Gather 'round the table,
One and then the next—
Children at the altar,
Blessed!

We must be polite
To the lord of our dinner time—
A social emperor in his throne!

He sets the tone—
We're everyday guests in Ahab's home.
Alas, I'll always be a butterless man!

Three bites of salt beef,
Stubb begins to stir—
Time for me to leave now,
Still hungry.

Farewell Flask,
Farewell Stubb,
Farewell Starbuck.
Doughboy set it up for our harpooneers.

Doughboy! Doughboy! Beef, Doughboy!

There once was a Doughboy, fat and tender,
He made a grave mistake!
He didn't feed his cannibals,
And his cannibals…ate him.

We must be polite
To the lord of our dinner time!
A social emperor in his throne.

CALL ME ISHMAEL ➤ *Patrick Shea*

He sets the tone—
We're everyday guests in Ahab's home.
Alas, I'll always be a butterless man!

Dinner, Mr. Starbuck.
Dinner, Mr. Stubb.
Dinner, Mr. Flask.
Yeah!

Time for me to leave now,
Still hungry!

CHAPTER 22
Merry Christmas

Based on belief, it wouldn't be logical
Charging a man to tame the depths of all,
Much less a man so touched when on the battlements.

A bet the devil would make
In Old Testament days
With God, so celebrate
A merry Christmas.

Sing to the sea, your words of milk and honey,
Warm through my heart to stand against the chill,
Pounding with strength still cresting from the darkest day.

A bet the devil would make
In Old Testament days
With God, so celebrate
A merry Christmas.

Our pilots disembark,
Return to lee.
Three cheers for open water,
No traffic.

Based on belief, it wouldn't be logical.

CALL ME ISHMAEL ➤ *Patrick Shea*

CHAPTER 6
The Street

Freaks and dudes
Are finally intermingling!
Freaks and dudes
From agitating sea!
Shadows cast,
A flame in every window.
Pallid sheen
In the beacon of dreams.

Bloomed from the crags,
Terrific altarpiece of meticulous fiends.
Shade joining hands
With every gift of creation
From negotiable light.

How now,
A yet unrealized prerogative
Of nations
Professed to welcome the world!
How now,
A yet unrealized prerogative
Is here,
On the outpost of time.

Freaks and dudes
Together on the corner!
Freaks and dudes
Embracing one another!
From the rocks
A flower of gentility
Blooms beside
Every sibilant tide.

How now,
A yet unrealized prerogative
Of nations
Professed to welcome the world!
How now,
A yet unrealized prerogative
Is here,
On the outpost of time.

CHAPTER 24
The Advocate

Listen here, I've had enough of this shit,
Saying whaling is only for scoundrels (What?),
That it's a dirty (Huh?), filthy (Who?), job for the base (Uh-uh!),
That we're barbarian butchers at sea.

Tell me now of those soldiers you host
In the highest company (Uh, uh!).
They're the bloodiest butchers you'll ever meet
But they'd buckle at the sight of a fanning tail (Oooh!).

For what are the terrors of man,
Compared to the terrors of beasts?

Our whaling ships are at the edge of the world
Bringing peace and information (Uh-huh!).
We're diplomatic, democratic, and we spread it around;
We've liberated colonies!

They say that whaling's not respectable,
Although the English call whales "a royal fish."
But they insist (uh!), persist (uh!), they never let up (uh-uh!)
Saying there's no good blood in our veins! (Say what?)
They say there's no good blood in our veins! (Nuh-uh!)
They say there's no good blood in our veins!

(Haven't they heard of Benjamin Franklin,
Democratizer, father of nations?
His grandmother, a woman of whaling,
The matriarch sent her family a-sailing!)

I know…I know…I don't understand it.
Maybe they're just scared:

For what are the terrors of man,
Compared to the terrors of beasts?

We make the world light up!

CALL ME ISHMAEL ➤ *Patrick Shea*

CHAPTER 30
The Pipe

May smoke rise 'round the bends
Of crows feet and ascend,
To waft serenity
Over snowy mountains.

When breaths jerk nervously
In panic, not relief,
The death knell's rung in vain,
For where's the warning?

To thrones of ivory white
The counselor councils right
That naught's compulsory,
Just rule the moment.

Slipstreaming over pools of disaster—
All ending by and by, so lead the ending.

CHAPTER 7
The Chapel

So you say, when we pass away,
Our bodies go into the Earth
And never come to be
Another happy memory,
And our souls will live forever
In the mountains of the heavens,
Making memories.

And what a relief, choosing to grieve for death instead of absence.
You'll no longer share threads of a common tapestry,
But the story goes on.

It gave you pause, made you hesitate
To give the last permission,
For the moments in between,
Could change your course away from me,
And those moments last forever,
And you had them in the absence
Of my memory.

And what a relief, choosing to grieve for death instead of absence.
You'll no longer share threads of a common tapestry,
But the story goes on.

CALL ME ISHMAEL ➤ *Patrick Shea*

CHAPTER 52
The Albatross (part 2)

When you leave your family behind,
You'll end where you started
Or die while you're trying.

The sea presents an abyss,
The mouth of a labyrinth,
The end of a tryst.

'Round the world is coming back to you.
'Round the world will take me back to you.

If the world spread out like a table,
Forever an eastward
Direction to take,

The wanderer would be able
To think of a better
World yet to come.

Don't you know your demons aren't at sea?
Demons are the circle that binds you.

The circle of our world is just a cage.
The circle of our chests is just a cage.

CHAPTER 45
The Affidavit

I'll testify to the reverend's holy words:
All truth told here.
It's your choice to believe it,
Irrevocably.

I've seen it thrice—embattled monsters torn
From dealing fateful blows,
Brought back after years gone by.
Death follows.

No simple brute—a thoughtful, malicious eye
Turns back assault,
And stove in many leaders.
Irrevocably.

You will never be
Broken, lest irreverent
To powerful things
When you face them.

Haughty disbelievers knocked from donkeys
On the road to Damascus.
It's your choice to believe it.
Death follows.

CALL ME ISHMAEL ➣ *Patrick Shea*

CHAPTER 128
The Pequod meets the Rachel

They died last night; they died last night,
Certainly.
They died last night; they died last night,
Certainly.

A pale unceasing cannonball
Struck from sheltered lee.
Carried by the cannonball,
Buried in the sea.

They died last night; they died last night,
Certainly.
They died last night; they died last night,
Certainly.

Listen as their spirits scream,
We heard them all last night.
Ghost ship sails for ghost beliefs,
Sweeping tack for any sight.

They died last night; they died last night,
Certainly.
They died last night; they died last night,
Certainly.

Abraham is unmoved,
Stable in the old roots,
Fathering a nation of
Hollow belief, and resolve.

Any circle broken
Makes the center shift and
Every spoke in kind will
Follow its lead, finding home.

Pack our Rachel up again,
Send her on her way.
An arrow loosed, we've joined the work
Three weeks from today!

CHAPTER 52
The Albatross (part 1)

A clap of thunder,
A bolt of lightning,
The crash of two wakes as they cross in open sea—
It's foreshadowing
Death and destruction,
'Cause the boat we passed was an Albatross by name.

A bird of good omen
Shot by Ahab—
What an arrow be the name of Moby Dick!
The captain faltering,
The Albatross dumbstruck,
Now we're cursed to be the walking dead for sure.

Hasn't he read
"The Rime of the Ancient Mariner?"
Doesn't he know
"The Rime of the Ancient Mariner?"
Every good sailor knows you let the albatross be!

Somebody read
"The Rime of the Ancient Mariner"
Out to the captain
(The Rime of the Ancient Mariner),
So we're all on the very same page while we're in the same boat.

Birds that scatter
As a portent,
Because of their supernatural sense of evil to come.
We had schools of fish
Scatter like birds—
Even Ahab noticed with sadness of our fate.

Hasn't he read
"The Rime of the Ancient Mariner?"
Doesn't he know
"The Rime of the Ancient Mariner?"
Every good sailor knows you let the albatross be!

CALL ME ISHMAEL ➣ *Patrick Shea*

Somebody read
"The Rime of the Ancient Mariner"
Out to the captain
(The Rime of the Ancient Mariner),
So we're all on the very same page while we're in the same boat.

Volume III

Afterword to Volume III

 I'd like to note that I don't consider myself to be an expert on *Moby-Dick*. I'm not an academic; I haven't spent any extraordinary amount of time studying the book, or Melville's letters or journals, or social context, or any other resource that might give me outstanding insight, nor have I surveyed any field of existing critical analysis. Part of the idea behind this project is that I had a strong personal reaction to this particular book, and wrote songs from those reactions. Interestingly, I'm not sure that Melville would distinguish between the two approaches. Throughout *Moby-Dick*, we see that the viewer imbues people, things, and events with unique meaning, as filtered through that viewer's unique set of experience and knowledge. In a way, approaching the book purely as myself is what makes the interpretations interesting, if not always useful or original, or even accurate.

 As I wrote these songs, I found that there are two ways to approach the interpretive task. One approach involves more or less retelling the chapter. In these songs, the interpretation hinges on what information I choose to focus on, and how I choose to frame that information. In "The Cabin Table," Ahab and the mates ask each other to the dinner table in descending order of rank. I made these invitations a prominent part of the song, and I accompanied these invitations with a somewhat melancholy chord progression and vocal melody to suggest something unfortunate and oppressive (and not all that cordial) about structuring mealtimes around rank. Once at the table, the mates can't take freely of the butter, having to wait for a superior to partake first. The sadly humorous detail of Flask never getting any butter because he's third mate led me to accompany this part of the song with a bouncy, pop hook, to make it seem all the more silly or absurd. The third part of the song involves the cannibal harpooneers, who break these conventions entirely by leveraging the cooks' racist fears—the cooks feed them well so the cannibals won't eat them—and that felt like an all-out carnival of chaos to me, which I tried to recreate in the piano and vocal arrangements. I think this approach can be interesting because up front the song seems like a straightforward retelling—my interpretive choices are subtext.

 The other interpretive approach is far more overtly personal. I think about what the chapter means to me, and abstract details from the book to present the interpretation as the chapter. "Brit" is itself a collection of reflections and abstractions, with almost no plot, about dichotomies of external and internal, conscious and subconscious, visible and profound. The main way that Ishmael presents this dichotomy is by following his gaze limitlessly upward from the surface of the water, and back down again, noting that his gaze can't begin to penetrate the ocean's depths. In other words, half of all the things in existence remain hidden below some kind of surface, and part of the job of being human is to penetrate that surface to learn what lives there. Boats literally break the surface of the water, and a voyage on a boat figuratively breaks the surface of our everyday reality, helping a voyager understand the deeper truths of the human experience. Something seems very lonely to me about living thoughtlessly through a day or an entire life, not trying to break that surface to better understand what we're all about. I started to think that part of the folly is that we've created a dichotomy in the first place, rather than seeing the conscious and unconscious as one functional, unbreakable whole, none

CALL ME ISHMAEL ≻ *Patrick Shea*

of which can be considered except in the context of all. This last thought is mine, and doesn't come directly from the book, but it was an important part of my reaction to the text — so much so that I turned it into the repeating chorus.

In either approach, my goal was not to recreate *Moby-Dick* in song, but to think about *Moby-Dick* in song, and to offer those thoughts to others who share my love of the book. It's the best I can offer, and likewise to those with a similar task at hand, it's the best I could receive.

CALL ME ISHMAEL

VOLUME IV

CALL ME ISHMAEL ➤ *Patrick Shea*

CHAPTER 90
Heads or Tails

Heads I win, and tails you lose,
I will take your whale if I so choose,
And if that peasant he should whine,
Papa king claims rights divine!

Heads I win, and tails you lose,
Cry to clergyman from weathered pews,
And if that clergyman should write,
Papa's got law on his side.

The king gets the head and the queen gets the tail
And there's naught in the middle in the whole of the whale.
Complain if you wish, and beg if you dare—
The king's law is always fair.

Heads I win, and tails you lose,
What a backward land when monarchs rule,
And I guess those peasants there resigned,
'Cause they don't demand what's thine!

The king gets the head and the queen gets the tail
And there's naught in the middle in the whole of the whale.
Complain if you wish, and beg if you dare—
The king's law is always fair.

CHAPTER 91
The Pequod meets the Rose-bud

From the heart of the stench,
A rose-bud blooms,
A rose-bud blooms for the day.

The brilliant devise
A posture to prize
The moment's luck from dismay.

As adjoining streams
Join as one, kneeling
Through the banks of probable decay,
Cannot claim perfume
Into rotten wounds,
May your sweetness live above the day!

Tides of the stench
Will ebb and flow,
And you, untouched, my Amber-Gray.

As adjoining streams
Join as one, kneeling
Through the banks of probable decay,
Cannot claim perfume
Into rotten wounds,
May your sweetness live above the day!

From the heart of the stench
A rose-bud blooms,
A rose-bud blooms for the day.

Tides of the stench
Will ebb and flow,
And you, untouched, my Amber-Gray.

CALL ME ISHMAEL ➤ *Patrick Shea*

CHAPTER 8
The Pulpit

Climbin' up the pulpit, as a ship at sea.
Isolate your sermon, lofty like a priest.
At the prow:
Symbolism now!
So we set the stage
From a random page.

Every affect, image, turning of the leaf
Doesn't carry meaning deeper than the brief
Dropped impression:
Lightness isn't heaven.
But oft it goes,
The tempest of our woes,

Whether a lost, forgotten captain,
Or rebel to shake the wrath of God.

Through the door, a mass of idiosyncrasies:
With the shell of sailors over suit to preach.
Old and bright,
Fascinating sight,
But a man the same,
Don't forget his name.

Whether a lost, forgotten captain,
Or rebel to shake the wrath of God.

CHAPTER 42
The Whiteness of the Whale

A study in white
Surrounds every taker—
Imperial blight,
Terrifically pure.
Desolate glaciers found at great heights,
Cold and unloving in the next life.

With every color
Layered in turn,
The sum of creation
Is empty in full.
Pure in its essence, but a nothing.
Are we perspectives on a nothing?

In death, the body's pallid—
As spirit drains away
The vessel's overflowing.

A color to mask
Each kind of decay—
The specter of white
Implies every corruption.
Purity's nothing but an absence.
Cleansed of the human, now an absence.

In death, the body's pallid—
As the spirit drains away
The vessel's is overflowing.

CALL ME ISHMAEL ➤ *Patrick Shea*

CHAPTER 54
The Town-Ho's Story

In the conduit connecting the animal to nature,
Born and bred a wretched beast—the intellect abstracted.
Be it anchored in the heavens or deep into to soul,
It can move a mountain peak.

Ocean to ocean,
No contradiction meant
From motion to motion.
Take your position
And reside there forever!

Every act of violence punished by punishment's creator.
Exorcise your will in peace.

Ocean to ocean,
A move towards democracy
From motion to motion.
Take your position
And reside there forever!

CHAPTER 67
Cutting In

Hey! You couldn't find me a better way.
It's modern ingenuity!
And with the strength that we get from science,
Bend we to the gods.

You couldn't find me a better way!
You couldn't find me a better way!

Hey! So with a pulley we move a mountain,
But there's a ritual involved,
So in a circle we worship nature,
The gift that made us gods!

You couldn't find me a better way!
You couldn't find me a better way!

Hey! And so lift up our voice in song,
And bow before the harvest sung,
And for machines making us efficient,
Bend we to the gods!
Bend we to the gods!

CALL ME ISHMAEL ➤ *Patrick Shea*

CHAPTER 59
Squid

Matterhorn, now rising from the ocean—
Twisted form as roots into the deep.
As the mountains
Reach down and down
To the brimstone, the Kraken grasps the sea.

Nest of snakes, to blindly rip asunder
Hapless souls who chance into their reach.
Widen berth
From sin and sorrow—
Let The Whale drive him to the deep.

But beware (beware!),
As the weight descends
A whirlpool left behind.
So beware (beware!),
From the oceans fair,
Damnation grasping thee.

Though they say, the rising Whale as portent,
Bringing 'round the fateful end of days,
It's the Kraken
That rises with Him
In the fray, will shatter all the world.

CHAPTER 99
The Doubloon

A thing yet precious in itself,
Stamped with the symbols of a collective memory,
And then stamped again, each eyes
Create reflections in the ridges, shaped alike.

And a man can filter text through any text,
And a man himself is text filtering text.
Come along and write the world with me!
You make me precious, and I make you precious.

I look, you look, he looks; we look,
Ye look, they look are crazy as a thing can be.
And we recognize these truths,
And yet oblige the process, meaning be the rule.

And a man can filter text through any text,
And a man himself is text, filtering text.
Come along and write the world with me!
You make me precious, and I make you precious.

A thing yet precious in itself,
A purpose at the center of our waning lives,
It's a story that we make—
Unscrew the navel and will everything unwind?

And a man can filter text through any text,
And a man is but a text filtering text:
Come along and write the world with me!
You make me precious, and I make you precious.

CALL ME ISHMAEL ➢ *Patrick Shea*

CHAPTER 27
Knights and Squires

Bumbling nobility paired with strength
Provides a might without right, Oh!
Led underestimating the majesty,
The gravity gracing us.

How could I breathe
A little of each nightmare
Sighed in all dying breaths?

God of the air
Medicated with camphor,
Block miasma of empathy.

Stout, earthly travesty led with ignorance,
The dirt in its fearlessness.
Never to feel the depths, even
Face to face, all sublimity wasted, Oh!

Nothing to move
The mountain of your violence,
Even battering waves!

Man of the world,
Yet braced against the influx
Of our tremulous days.

Rally the backs,
The strength of every island
Pitched at banners of eloquence.

Only the wretch,
The touch of something deeper,
Will be graceful on high.

CHAPTER 100
Leg and Arm—The Pequod, of Nantucket,
meets the Samuel Enderby, of London

You gave a leg and I gave an arm—
Let's shake bones together!
We thrilled for the Whale; we both came to harm—
In whiteness stained forever.

Both taken by the do-run-run—
Where the lust begun
I can't begin to say.

Once clinging to a grim resolve,
And so our flesh dissolved,
It melted away!

Our doctor's a drunk; he left me a stump,
Presenting Dr. Bunger!
"The captain, that man, with hammer for hand,
Clubbed me in a passion!"

(both:)
Oh Bunger, you're a rascal, man / Oh Boomer, so facetious, man
You didn't feel my hand / I never drank a dram
No matter what you say! / No matter what you say!

Oh Bunger, nothing like you man!
"And neither you, captain!"
(both:)
We'll laugh all the day! / We'll laugh all the day!

You gave a leg and I gave an arm—
Let's shake bones together!
We thrilled for the Whale; we both came to harm—
Let's shake bones together!
Let's shake bones together!

CALL ME ISHMAEL ➤ *Patrick Shea*

CHAPTER 77
The Great Heidelburgh Tun

Great cask of delicious wine
Built 'neath the castle floor
As a sign of the bounty of our righteousness,
As a crown on the kingdom's store.

Whoa-oh, Whoa-oh!
Guard your luxury!

Great wax of a class divine
Sought for appearance sake.
As they smooth every wrinkle from an aging face,
Does the face turn collectively blank.

Whoa-oh, Whoa-oh!
Guard your luxury!

Great tun on the monster's mind,
Promised and plentiful,
So take care with the lever on the guillotine
Lest you spill it on the castle floor.

CHAPTER 14
Nantucket

The thief who thieves from countrymen
Is a vicious criminal.
Heroes cast their empires wide
As a noble blanketing.
Mining yet through surfaces
To extract the best from all.
As oil on water brings a darkness
The heroes' shadows fall.

An island born from Heaven stealing
The future of the Earth,
Rests its head atop the ocean,
A proxy one for each.
Friends and lovers laugh together,
The rape's relentless cry,
A barren desert gilded with
A villain's remedy.

Every surface serves as but
The monster's wherewithal.
A push defined by that to push
Makes a gift of boundaries.
Life in placid infinite,
Though a paradise in form,
Tortures spirits' needs to break
Into other peoples' homes.

CALL ME ISHMAEL ➢ *Patrick Shea*

CHAPTER 81
The Pequod meets the Virgin

Who knew, under placid waters,
King Erudition writhes?
Barbed by weaker opposition,
Pitied for muted cries.

Were it head on, no one could resist him,
Strength of a thousand thighs,
But with one prick, hiding in the water,
King Erudition writhes.

And I, I, I,
Heavy with a grievance, heavy with a grievance.
And I, I, I,
Heavy with a grievance, heavy with a grievance.

The good folk, dark if for the pity
Man brings to suicide.
With a cheek turned, live your final moments
Deep in a ponderous mind.

And I, I, I,
Heavy with a grievance, heavy with a grievance.
And I, I, I,
Heavy with a grievance, heavy with a grievance.

CHAPTER 68
The Blanket

The skin of a man does tell of his history.
The skin of a man is thin as the breeze.
The skin of the whale is written as mystery,
Scarred in the vast, unspoken sea.

Learn your lessons from his presence,
Lifeless, laid at your feet.
Thick skin, blessed warmth, and refuge
Need a man to survive.

Much as the whale, does man need an inner warmth,
Though banished to live out his days in the cold.
Much as the whale, is man but a stranger
On the Earth he calls his home.

Learn your lessons from his presence,
Lifeless, laid at your feet.
Thick skin, blessed warmth, and refuge
Need a man to survive.

CALL ME ISHMAEL ➤ *Patrick Shea*

CHAPTER 118
The Quadrant

Angled reflection,
But to sweep the sky will never tell why,
Only the present
Where the see-er stands alone.

Rational repose—
You can bend and strain with nothing yet gained,
Then the descendance,
In a fiery slide we go.

Astral projection,
Behind all things, the knowledge of scenes
Dealt as invective,
So burn your fires bright.

CHAPTER 28
Ahab

All but consumed by fire,
As in spirit, the body tempered—a cast alive.
Scar from tip to toe
From a battle, perhaps with his very birth.
But the wise man points to the elements,
As the fire locked jaws with the ocean, hence.

Stands on an effigy
Of the jaw that did undermine his stability.
Anchored upon the tip
In an auger hole of his firm resolve.
With a gaze clamped tight to the infinite,
Could a faltered captain lose his grip?

High times for all!

Still but to watch and wait,
No excitement of purpose to drive the clouds away.
Creases upon his brow
From the weight of a wrecked principality.
But the tropic air dances casually
'Round the crags of Ahab, softening.

High times for all!

But the wise man points to the elements.

CALL ME ISHMAEL > *Patrick Shea*

CHAPTER 134
The Chase—Second Day

It's the worst could happen
Every waiting day:
How could darkness pass away?

In the early morning
With a captain's grace,
Soon foretold to whence we chase.

With the wind an ally
And the sea to speak,
Brought us place, pernicious.

Thundering breach, froth, and majesty
Tore into view.

And he took us head-on,
And we circled free,
And I lost my death in thee.

Every beacon splintered
In a punchbowl sea.
Firstly, cradled; lastly, leaned.

Would I have leaned any oftener!
Would I have leaned!

CHAPTER 26
Knights and Squires

His skin's a blotter
Drawn tight, memory of the water.
Stalwart beacon of courage,
Raised in the day.

He's superstitious
But smart, blessed with inner visions.
Full sail, brave with the horrors
Staged from the earth.

I sing of stronger
Degrees of honor
Than kingly riches,
Shone from the work of man!

But, lo, he falters!,
Faced with supernatural horrors.
Come, friends, brace him with his blemish,
As one we fall!

In every fellow
Exalt purity of spirit
From dust, rising to the glory
Of functional.

I sing of stronger
Degrees of honor
Than kingly riches,
Shone from the work of man!

CALL ME ISHMAEL > *Patrick Shea*

Afterword to Volume IV

A number of songs on *Call Me Ishmael: Volume IV* make this a good time and place to talk about symbolism in *Moby-Dick*, and how my thoughts on Melville's treatment of symbolism affected my songwriting. First and foremost among these chapters is "The Doubloon," a chapter of near meta-fiction in which Ishmael watches a number of his shipmates decipher the symbols stamped onto the doubloon that Ahab nails to the mast in "The Quarter-Deck." Each man sees something different in the doubloon's images, according to (presumably) his own unique set of experience and knowledge, that part of each of us that we think of as self. Queequeg takes this idea one step closer to obvious as he interprets the doubloon through his tattoos, literally reading himself as he reads the doubloon. Then we realize that we hear each character's interpretations as relayed through Stubb, who narrates his own experience of watching each man approach the doubloon. And since Stubb's observations appear in quotation marks, we realize that we're actually hearing each man's observations as viewed by Stubb, as viewed by Ishmael. In all of this, I think we're meant to realize that nothing in the world, and by extension literature, has any meaning independent of the viewer's perspective, that there are no such thing as symbols, only what we choose to think of as symbolic.

What then of "The Whiteness of the Whale," a chapter devoted entirely to discussing the symbolic significance of Moby Dick's whiteness? What of "The Pulpit," with its Father Mapple climbing into a prow-shaped pulpit dressed as much as a sea captain as he is dressed as a priest? What of "Ahab," with all of his fire imagery, and Fedallah the parsi for a bowsman? My best answer is that we're supposed to be conscious of the fact that the story of *Moby-Dick*, as any story, is told through the eyes of a narrator, and that all significance applied to objects or events is the significance applied by the narrator. We can then interpret the fine parsing of symbolism in "The Whiteness of the Whale" as being a process of basic human nature. In thinking about Moby Dick (the whale), one might ask of himself a series of questions: why does that whale terrify me; is it his whiteness; what terrifies me about whiteness; i.e., what does whiteness mean to me that I find it so terrifying? As we hear Ishmael answer these questions for himself, we learn about Ishmael, and what makes him uniquely Ishmael.

I think we're also supposed to realize that we as readers read any given book similarly, thinking perhaps that we see absolute significance in the text, but really seeing only ourselves reflected in each page. I've talked to a lot of people about *Moby-Dick* in the past few years, and I've heard a lot of intelligent and coherent ideas of what the book is ultimately about, all spoken with absolute conviction and near-epiphany. Strangely, I've never heard the same interpretation from two different people. I haven't even heard two interpretations that are anywhere close to relating to each other in any way. I've realized in the course of these conversations that in each interpretation, I'm hearing something profound about the reader, which has nothing at all to do with the book. It's like hearing someone talk about a fever dream.

In the process of writing all of the songs for this project, I made a point not to latch onto any one interpretation of the book. I didn't think it would do the book justice to render it in allegory or extended metaphor. I also did my best to always be aware of Ishmael's interpretations as being Ishmael's, and Ahab's interpretations as being Ahab's, etc., and to not confuse these

interpretations with some absolute truth. Most importantly, though, I took the opportunity to think about my own interpretations as being mine, and in so doing, to learn more about what makes me uniquely me. Capturing fragments of those deeper self-truths is what songwriting is all about, both as an initial experience of writing, and as an end experience of listening. For me, *Moby-Dick* provided fertile ground for that process, to say the least.

CALL ME ISHMAEL > *Patrick Shea*

CALL ME ISHMAEL

VOLUME V

CALL ME ISHMAEL ➣ *Patrick Shea*

CHAPTER 48
The First Lowering

The more the merrier!—
Come out of the heat, and they're pulling beside.
There's noting scarier
Than losing a whale while you pray to the sky.

Those devils are good fellows, too!
You see them row, and the rowing's proof!

Break your back on it!—
An angry dog with a knife his teeth.
But don't belabor it—
You're nodding off, like a day at the beach.

Now hail ye, Starbuck, pull aside,
Have you seen such sights in the whole world wide?

Oh, the whales abound and the action's nigh!
With duty, our profits will rise and rise!

Look thee out at the deep, dark blue—
The ocean's looking at each of you!

And now, prepare you
To chase your death to the heart of a storm.
With hearts of caribou
We tarry on, and we're never undone!

Now whale and squall and harpoon are one,
With hope aloft in the setting sun.

CHAPTER 76
The Battering-Ram

May Truth reveal itself
In moth-fed predilections,
Furnished by the wealth
Experience conditions,
So we do it!

I can't conceive your eyes,
But I don't care.
Maybe another day.

In all precedes a form—
A wall of indivision,
A cold protecting warm
In palpable commission,
And so we charge ahead.

Behind it all, amassed,
Tremendous life,
Or so I see in you.

But take, take, take, take, take, take, take it easy!
Now believe each fateful sight!
A wonder in every fold,
A truth waiting to be told!

A youth who steals the path
From timely revelation,
When sorrow takes it back,
Dies in observation
Of the only Truth.

I can't conceive your eyes,
But I don't care.
Maybe another day.

CALL ME ISHMAEL ➤ *Patrick Shea*

CHAPTER 43
Hark!

"Hey now, comrade, something is coming our way!"
"Keep your mind on the task at hand, or be gone!"
In labor we were silenced all along.
"The captain sleeps below us, so be what you be."
In deference, we change the truth that we see.
The ocean's rolling!

Shake it, shake it, shake into the shadows beneath!
The shuttered silence awoken, we are free!
Shake it, shake it, now,
Shake the stern to the bow!

In labor we were silenced all along.
In deference, we change the truth that we see.
The ocean's rolling!

Shake it, shake it, shake into the shadows beneath!
The shuttered silence awoken, we are free!
Shake it, shake it, now,
Shake the stern to the bow!
Shake it, shake it, now!

CHAPTER 101
The Decanter

Oh, everybody knows you're an Englishman,
Leaning with a beer on the still capstan.
A party in the bow, with beef to pass around—
Oh, you're out of sight!

Extend your generous hospitality—
We're worked to the bone.
Whether it bull-beef or dromedary,
It's more than I've known.
And so we sing it!:

Make me an Englishman,
His life is for me!
Never to lift a hand,
Without some relief!

That's how we sing it!

Oh, everybody knows you're an Englishman,
Dizzy in the head when you're harpoonin'.
You throw it in the dark, but always hit your mark—
Oh, you're out of sight!

And so we sing it!:

Make me an Englishman,
His life is for me!
Never to lift a hand,
Without some relief!

That's how we sing it!

CALL ME ISHMAEL ➤ *Patrick Shea*

CHAPTER 106
Ahab's Leg

Joy from joy,
And misery from misery!
Sadness suckles at your breast again.

The weight of depth,
Enough to crack your deadened half,
Could never leaven with felicity.

And on through the endless history of the seeds of pleasure,
Belayed to the promissory of despair, oh!

So we're caught,
Contemplative, but for our lot—
Each ambition with decent of pain.

Brace us now,
And live we for the where and how!
With practicality I stand, estranged.

And on through the endless history of the seeds of pleasure,
Belayed to the promissory of despair, oh!

Credit given in forbearance's name,
Nothing given to enjoy the same.

And on through the endless history of the seeds of pleasure,
Belayed to the promissory of despair, oh!

Joy from joy,
And misery from misery!
Snakes and songbirds do beget the same.

Brace us now,
And live we for the where and how!
With practicality I stand.

CHAPTER 9
The Sermon

Purge your pride, in the belly of
Desire, in the valley of
Required opportunity—
Delight in obedience.

The flame burns true as a compass, there's
No skew on perspectives you
Want to simply justify—
And so do you slumber.

But, oh!
The hand of God is up above!
And, oh!
You cannot run from boundless love!

Carried down with a tempest of
Renown, to the stillness of
Each round individual sphere—
Peace now is a punishment.

So beg your Lord for the trying reward
Bestowed for the congress of man,
Each lost in his wickedness—
And so, with your pilot!

And, oh!
The hand of God is up above!
And, oh!
You cannot run from boundless love!

CALL ME ISHMAEL > *Patrick Shea*

CHAPTER 35
The Mast-Head

Saint Stylites on a pillar in the desert,
What is he looking for?
Like a priest in the tower of Babel—
What is he looking for?

Stand we now fast to the columns of grandeur,
As a colossus, yeah!
Up in the trees, with the world overflowing—
What more to conquer, hey?

Here do we sway; destitute,
Languorous days; amplitude
Of the humble-most waves
Move us far and wide.

See Captain Sleet, high and mighty in the crow's nest—
A token advantage, oh!
Power reduced to convenience, common pleasures
Painted a noble hue.

And we, not bemused
For exposed through and through!

CHAPTER 64
Stubb's Supper

When I die, I'll go to heaven,
When I die upon the sea.
When I die, I'll go to heaven—
The blessed angels will deliver me!

Stiff of leg, with nature's reason,
So the minstrel shows betray,
But I'll preach another season
To the sharks who wouldn't listen to be saved!

Oh, they feed upon the river,
And they feed upon the sea,
And they feed until they wither
With the burden that they gathered in their greed.

Sharks own the river,
Sharks own the sea,
Sharks don't deliver,
But the blessed angles will deliver me!

When I die, I'll go to heaven,
When I die upon the sea.
When I die, I'll go to heaven—
The blessed angels will deliver me!

CALL ME ISHMAEL ➤ *Patrick Shea*

CHAPTER 122
Midnight Aloft—Thunder and Lightning

Um, um, um.
Um, um, um.
Every snowflake in the winter,
Every lightning bolt in spring,
Every gift the Earth is given,
Is given unto me. (Given unto me!)

Um, um, um.
Um, um, um.
At the bottom of the order,
Every dangerous task in need
Is given unto me. (Given unto me!)

The sky, undone,
Overthrown,
Daggers flashing off and on.

And I sway,
Dearly clung
To the lightning rod.

Um, um, um.
Um, um, um.
When the white man touched the metal,
That would bring the lightning nigh,
Well, you thought the man defiant
And crazy, by and by. (Crazy, by and by!)

But you sent me to the rigging,
Climbing to the sky! (Climbing to the sky!)

Um, um, um.
Um, um, um.

CHAPTER 123
The Musket

Spinning in the storm,
An angel adored me,
Tempted my escape from every claimant,
And we'd take the open sea,
And turn it around.

A token of the war
In every arrangement
Made between a man and that which taints him—
It's a life to overthrow,
May heaven allow.

Tell me, could it be the loss,
The stinging loss
I feel in every dream? In every
Meaning lost to waves in rugged sea?

Here I stand alone,
At opposite corners
From my only duty as I claim it—
Can I take the open sea,
And turn it around?

CALL ME ISHMAEL > *Patrick Shea*

CHAPTER 71
The Jeroboam's Story

All heaven would delight,
Heaven would delight,
If the sing-song charlatan a-blowing his horn had never been torn
From permanent night.

Cry "hell!" until you're right,
You'll always be right—
If you hem and haw wide as Arkansas, you'll probably draw
Inside of a straight.

Oh, but you're wrong,
You'll always be wrong,
You offer damnation,
You offer mistakes.

Give me the law,
Let me be strong,
Give me salvation.

No angel would affright
The way you affright.
You feed their fear so that you can steer them far and away
From nature's right.

Oh, but you're wrong,
You'll always be wrong,
You offer damnation,
You offer mistakes.

Give me the law,
Let me be strong,
Give me salvation.

All heaven would delight,
Heaven would delight,
If the sing-song charlatan a-blowing his horn had never been born.

CHAPTER 111
The Pacific

A dream rolling over me,
Rolling on; the sea
Rolling over me.

A dream rolling on,
The sea touching all—
Receive of the harmony.

Out over the ocean,
I feel every notion
Of peace, and of suffering.

In every great undulation,
Every soul, every patient
Belief, every broken sleep.

A dream rolling over me,
Rolling on; the sea
Rolling over me.

A dream rolling on,
The sea touching all—
Receive of the harmony.

Just as the sea touches rivers
In the valleys, as they quiver
From hearts to humanity,

Each of us touched and delivered
By the shadows and glimmers
Of all time, of all human beings.

A dream rolling over me,
Rolling on; the sea
Rolling over me.

A dream rolling on,
The sea touching all—
Receive of the harmony.

CALL ME ISHMAEL ➤ *Patrick Shea*

CHAPTER 55
Of the Monstrous Pictures of Whales

Science could never relate
(With a partial view of the animal state)
A true description of whales,
That would speak itself to our animal fate,

Neither the stories of old,
Predetermined by man,
Prior to Noah, alone,
Floating over the sand.

Show me Platonian form,
And I'll show you one who has yet to have sworn
Blessings for each of the crew,
In the eye of fear, in the mouth of the storm.

Give out an animal wail
In its terrible face;
And draw it, as bravery pales
To indifference.

Give out an animal wail!
Give out an animal wail!
Give out an animal wail!

Fault can only be laid
When a man assumes all experience stale,
Lifeless, and easy to rate,
'Til the distance makes his illusion the same.

Lay out the soul of your soul,
A majestic array,
Tuned to the palpable, flawed
Imbrication of days!

Volume V

CHAPTER 133
The Chase—First Day

 (There she blows!) In every noble heart, an island,
(There she blows!) Dense with every woe a lesser man could feel.
 And his island has breeched in the heart of the sea
 With the heavens above and a mystery beneath—
 Birds aloft in joyous contemplation.

 (There she blows!) A gentle Jupiter, admired,
 (There she blows!) A pinion of serenity
 Set to work on the heart of a merciless hand
 That is raised, nonetheless, in the folly of man,
 Peace becomes a just and natural torrent.

 And he raised our boat in rows of ivory teeth,
 Then he made a safe retreat.

 (There she blows!) If gods would speak, it won't be omen
(There she blows!) That they choose, in all omnipotence, to bear
 Any deafening will that a god could command
 From the power of all to the weakness of man—
 Sails aloft, I speak but from an island;
 Sails aloft, I speak in open sea.

CALL ME ISHMAEL ➤ *Patrick Shea*

CHAPTER 129
The Cabin

Ahab:
Turn your trembling eyes,
Oh!, sacred tiller, wise
With empty paradise!
Let me force the way.

My illness will suffice,
Torn from the echoes,
To guide this grand device.

Pip:
Fully centered, so here I stay,
The coronation of king-for-a-day,
As I make believe a history to abnegate.

Ahab:
The hour is coming nigh—
Spun off the axis.
Oh, empty paradise!
Let me force the way.

No caprice or guile
Brought yet to sully
A dutiful demise.

CHAPTER 25
Postscript

Did you know
It's a key regal dignity, oh for sure,
To taste good?
He's a well-seasoned leader, a salty germ!

And all told,
At the grand coronation he's crimped and curled
With some oil,
While a holy significance gives the foil.

Take one, take two, take three,
Take all of it.
We view the rule of kings
As sodomy!

We know what kind of men are you,
Given fully to pompous fools.

So often,
A contemptible signifier for men,
Like or not,
Is the well-oiled nature of every lock.

Safe to say
That a king wouldn't use the same oil as they.
Fancy pants
Needs the oil from the free men who bear the lance.

Take one, take two, take three,
Take all of it.
We view the rule of kings
As sodomy!

CALL ME ISHMAEL ➤ *Patrick Shea*

CHAPTER 92
Ambergris

Three cheers for the atmosphere,
To good health in the coming years,
To all smells foul, and to the sweet aroma
Born from the wretched, blossomed in the corner.

Hey, hey, we're only what we own.
Hey, hey, we're gonna own the form!

St. Paul dancing at the ball—
From dishonor to the glory tall.
Wake, baby, wake—it's only in the water!
Change what you take, and change the holy order!

Hey, hey, we're only what we own.
Hey, hey, we're gonna own the form!

Wake, baby, wake—it's only in the water!
Change what you take, and change the holy order!

CHAPTER 135
The Chase—Third Day

You'll always be the suffering,

Come as a revival of our pride;
Chimneys, volcanic, break our lives
Back to the building blocks, inspired
By the mechanics of each grief.

You'll always be the suffering,

Come think of the beauty in her eyes;
Think on reflections in your child.
Make for the evening, come what may!—
We're better in bitter struggling.

You'll always be the suffering.

CALL ME ISHMAEL ➤ *Patrick Shea*

Afterword to Volume V

People often tell me that they are pleasantly surprised by the general tone of the *Call Me Ishmael* songs. People think of *Moby-Dick* as an extremely dark book—which it is—and so expect the musical interpretation of the book to be either angry or maudlin, or both. Instead, I wrote songs with a good deal of levity, even the melancholy ones, and many of the songs are downright upbeat and danceable. I have a couple of reasons for approaching the book this way. The most simple and straightforward reason is that for all its moments of darkness, I don't generally find the book to be all that dark. Ishmael, the angry young man who wants to knock the hats of strangers off of their heads in chapter 1, is also a riotously funny storyteller. Ahab, the man who lets his anger drive a ship and its crew to a watery death, rants at such frequency and length that it's hard to take him seriously. The men, who find their lives threatened almost daily by one thing or another, eventually have to see the whole thing—as Ishmael relates in "The Hyena"—as a great cosmic poke in the ribs. In other words, *Moby-Dick* is so dark that it isn't, and I think that Ishmael would make the same argument about the world in general.

But there's another angle to the general tone of these songs—a songwriting choice that I made in expressing tension by breaking it. "The Musket" is a good example of this choice. The chapter appears near the climax of the book, and presents us with Starbuck standing outside of Ahab's quarters with a gun, deciding whether or not he would be justified in killing him. If there is a more intense moment one could feel in one's life, I don't know what it would be. In fact, the moment is so overwhelmingly tense, that trying to write the tension into a song would ruin the tension in the same way that describing a monster actually makes it less scary. The better option, in my opinion, is to give Starbuck a danceable moment of musical theater, a moment of levity before the music stops and he either has to pull the trigger or not. The levity is itself tense because of what's waiting for the singer at the end of the song. For me, that tense levity approaches the reality of Starbuck's situation far better than a straightforward approach ever could.

"The First Lowering," "The Battering-Ram," "Hark!" "Ahab's Leg," "The Chase—First Day," among others, are other good examples of a similar choice made in different contexts, with different results. Somehow, laughing (singing, dancing) in the face of crisis is the darkest response imaginable, because it means that there's nothing else left to do. And that feels like a pretty accurate representation of *Moby-Dick* to me.

CALL ME ISHMAEL

VOLUME VI

CALL ME ISHMAEL > *Patrick Shea*

CHAPTER 124
The Needle

You sent me head over heels,
Lost in the peals of my
Heart as it reels.

Sailed headlong into the storm—
Nothing could warn me off you.

Oh, lightning but only strikes once!
Oh, lightning but only strikes in paradise!

My compass pointed me East,
On to defeat your
Magnetic retreat.

Proud compass spun me anew,
Shocked into running from you.

Oh, lightning but only strikes once!
Oh, lightning but only strikes in paradise!

Natural deceit turned me far from thee,
Ah, ah, ah, ah, ah, ah, ah!
What a great relief, the sun, so indiscreet,
A fiery wrecking ball.

Now, with a sleight of the hand,
I turn where I stand
In magnetic demand.

Once more, faced into the wind,
Nothing could keep me from you.

Oh, lightning but only strikes once!
Oh, lightning but only strikes in paradise!

CHAPTER 46
Surmises

Our purpose clear, it has begun,
But for every tool you count beneath the sun,
Only mankind's opposition,
From his fickle disposition,
Needs a careful kind of maintenance on the way.

We'll fight lick for lick,
We'll kill Moby Dick,
But we're gonna pick old Neptune's pockets
All along the way!
Our pious delight
Too far from our sight,
So we'll think about the money for today.

And not the least on Ahab's mind
Is the joy he reaps from killing Moby's kind.
Though he has a wife in token,
He is married to the ocean,
And he skips upon the waves of blood he laid.

We'll fight lick for lick,
We'll kill Moby Dick,
But we're gonna pick old Neptune's pockets
All along the way!
Our pious delight
Too far from our sight,
So we'll think about the money for today.

Our purpose clear, off in the distance
Swims a holy fish we seek with great insistence.
But that's many months in coming,
So for now the ship is running
Off the fuel of material desire.

We'll fight lick for lick,
We'll kill Moby Dick,
But we're gonna pick old Neptune's pockets
All along the way!
Our pious delight
Too far from our sight,
So we'll think about the money for today.

CALL ME ISHMAEL ➢ *Patrick Shea*

CHAPTER 11
Nightgown

The world is far away, oh!, far away
And my friend's near.
Underneath a blanket, oh!, with a friend
That I hold dear.

But our warmth would not exist without the cold,
As our loneliness, without someone to hold!
I'm glad I've got my friend!

Intertwine our legs, oh!, and our race
Is oh so clear,
But what is in our race, oh!, but a contrast
When two are near?

Well, at least we're here together, heart to heart!
Many others choose to live apart!
I'm glad I've got my friend!

Oh, our warmth would not exist without the cold,
As our loneliness, without someone to hold!
I'm glad I've got my friend!

The world is far away, oh!, far away
And my friend's near.

CHAPTER 116
The Dying Whale

Oh!, heed the compass of dying whales,
Thick in their blood, passing life away,
Spin in the ocean upon their tails
　To glance the living sun!

I'm nursed at sea!
Darkness buoys me!

Round and round, interceding jest,
A dance for the life-giving median,
A chance offered once at a god's request
　But not upon your death.

I'm nursed at sea!
Darkness buoys me!

Know you that after your begging breaths,
You turn full around to the obvious?
Banked in the passage of living breath
　Undone, condensed as one!

I'm nursed at sea!
I'm nursed at sea!

CALL ME ISHMAEL ➤ *Patrick Shea*

CHAPTER 104
The Fossil Whale

Big as it is, the whale is a fertile theme,
Varied and antediluvian,
The sea held a brand of leviathan
Before time carried the Earth.

Born on the depths of a primal mist,
Nursed with the reptiles-furious,
Ruled under ice caps and equatorial freeze—
Hard to believe!

And what I'm trying to say now,
There's a subtle line
Between the scale of the subject
And the thoughts brought to the mind.

Reach, yet, the distance of ancient lands,
Prior to Moses in Pharaoh's hands.
Touch ye the blood of cetacean prehistory,
With Ahab and me!

And what I'm trying to say, now,
There's a subtle line
Between the scale of the subject
And the thoughts brought to the mind.

CHAPTER 47
The Mat-Maker

Lazing on a cloudy afternoon,
While away the minutes, weaving.
Working at the warp of Time,
Summoning a life of my own dealing.

And chance drives the ribbon!
And chance drives the ribbon!
And chance drives the ribbon askew!

Then, by simple happenstance,
The mast-head cried, our destiny remembered.
Hop to stations, one, two, three,
Choice at bay, and free-will fully censured.

So chance drives the ribbon!
So chance drives the ribbon!
So chance drives the ribbon askew!

More than one way,
More than one way through,
More than one way through necessity!

We see it in the whale, as well—
He spouts with regularity, intriguing.
But beneath the surface he's
Free to follow any path he's leading.

But chance drives the ribbon!
But chance drives the ribbon!
Oh, chance drives the ribbon askew!

CALL ME ISHMAEL > *Patrick Shea*

CHAPTER 98
Stowing Down and Clearing Up

We walk in twos and threes,
How we promenade the well-trod boards,
As dainty lords, immaculate.
Though oft maligned, we're oft refined
By the guts and grime we scrub away.

Bring us midnight tea,
And the forecastle will be transformed
By highest born nobility.
We work and slave, and earn our days
To dab with napkins, so effete!

Sing-out, mast-head, sing!
Aristocracy in truest form
Is never worn in apathy.
In weary pacts, we break our backs,
Then birth, as phoenix, from the lye.

We walk in twos and threes,
How we promenade the well-trod boards,
As dainty lords, immaculate.
Though oft maligned, we're oft refined
By the guts and grime we scrub away.

CHAPTER 31
Queen Mab

Listen to me, Flask, a curious thing
Came to me as advice in last night's dream.
Ahab kicked me with his ivory leg,
Then his base widened to a pyramid.

I had a night to be
Alone, steeped in a wondrous dream.
Rise, oh, Queen Mab, arise,
And hush each of our players' sighs!

So I kicked his geometric strength
As I thought to myself at some great length—
He didn't kick me with a living foot…
It matters. It matters!

I had a night to be
Alone, steeped in a wondrous dream.
Rise, oh, Queen Mab, arise,
And hush each of our players' sighs!

Then a merman came to lecture me
On the blessed abuse of royalty—
Every kick from Ahab makes you wise,
And at least he didn't kick with common pine!

I had a night to be
Alone, steeped in a wondrous dream.
Rise, oh, Queen Mab, arise,
And hush each of our players' sighs!

Rise, oh, Queen Mab, arise,
And hush each of our players' sighs!

CALL ME ISHMAEL ➤ *Patrick Shea*

CHAPTER 39
First Night-Watch

We'll drink tonight with hearts as light,
To loves as gay and fleeting,
As bubbles that swim on the beaker's brim,
And break on the lips while meeting.

The captain's spite did fill the night
With terrors yet revealed.
Unfortunate gaffe, so let's have a laugh,
And hope that his head is healed.

I never foresaw such a good guffaw
From something so unnerving,
But destiny wins what our fate begins,
And life goes on, unswerving.

He gave the first mate an appropriate
Unsettled sort of feeling,
Just as I felt when the man did pelt
Me, sending me a-reeling!

I'm perfectly sane, but a merman came,
Bestowed me of a title.
A laugh, now, to dub the wisest Stubb
And save him from reprisal.

Never my wife, in her lonely life,
To cry and count my earnings.
She's having some beers with the harpooneers
And comforting their yearnings.

Every man shored to a higher lord,
Beholden to his bidding,
"Curses and balls!" Aye, it's Starbuck calls,
I must see what he's giving.

We'll drink tonight with hearts as light,
To loves as gay and fleeting
As bubbles that swim, on the beaker's brim,
And break on the lips while meeting.

CHAPTER 127
The Deck

Carpenter:
Sha na na na na!
No need to sing, the tools are ringing in song!
Sha na na na na!
But digging a grave, you bring the ditty along…
Still, indifferently, I cradle death, undone.

Sha na na na na!
I do as I do, you say to do it, it's done!
Sha na na na na!
There on the way, I needs be having some fun!
And in courting laughter, bathe in tempers won.

Ahab:
A sounding board in the house of the dead—
Echoes untoward!
Hold now, opine—every vector a straight line
Paired with this force!

CALL ME ISHMAEL ➤ *Patrick Shea*

CHAPTER 78
Cistern and Buckets

How the tragedy came to pass, don't ask me, now.
A heave of the sea, or the slippery, hypnotic prow,
Once a living device, now eighty buckets of paradise,
Sent him fully within the cavern of fibrous skin.

And then fallen away,
The head buckled and swayed,
As old ocean eloped
With young death on a rope—
Alarum now awoke!

No umbilical turned the womb into a precious tomb.
And so buried twice, once in a fragrant room,
Then in the infinite ocean of epithet—
Savage sunk in a savage beast, under savage moon.

And then, out for the save,
The midwife of the waves
With caesarian drowned
Birthed the man by the crown,
And broke the burial mound.

Wherein the mystique?
A death, bittersweet,
Claims curious life
In sweet essences rife
With unbroken form!

Volume VI

CHAPTER 40
Midnight, Forecastle

As the drunk wore off,
Found ourselves face to face with nature, crossed,
Found ourselves reckoning with peace, not lost
But conceded by the crew.

As the ballroom lee
Closed with an echoing finality,
And every dream of women chased recedes,
We brace up to meet the storm!

Of all things great and small,
It's the bending that relieves
The strain of pitch and yaw,
It's the ultimate belief
In nothing, not at all,
That engenders our survival, oh!

Reef the topsails now,
And reef your hearts, and steer your steady prow,
And kneel to thunder, and to lightning, bow,
With a kind felicity!

CALL ME ISHMAEL ➤ *Patrick Shea*

CHAPTER 60
The Line

From the bow to the far aft end,
Where you loop it 'round that post, my friend,
And then up the middle, touching every hand,
Ahh-oop! We're back again!

Now to the notch in the pointed prow,
Let it droop a little, down across the bow,
Coil a loop into the box for now
And then tie it to the harpoon, pow!

Each man sitting in a noose—
It's a funny feeling!
Precarious and quite perverse,
But it's life; it's every life.

Do your job at the counting house,
It's still a noose if you smile or grouse.
Or sitting quiet by the fire, I'd rather be you,
But you're still in a noose.

Each man sitting in a noose—
It's a funny feeling!
Precarious and quite perverse,
But it's life; it's every life.

Always threatened by the perils, love,
Of this mortal world, though you push or shove,
Or if you tiptoe around with new kid gloves,
Or you pray to the Lord above.

So, take advice from the lofty stacks,
And never worry; never watch your backs.
You'll never know it 'til you feel the ax,
So relax! You have to relax!

Each man sitting in a noose—
It's a funny feeling!
Precarious and quite perverse,
But it's life; it's every life.

CHAPTER 12
Biographical

Oooh, Kokovoko!

Think of an island, far away (Kokovoko!),
Lavished with splendors of a bygone day (Kokovoko!).
You left it with the dreams of a child,
You thought you'd only leave for a while, but now
You're far away from home.

Left with a purpose of high intent,
To bring every subject enlightenment,
To lift every dream of the land you hold so dear.
Corrupted in the very act,
A folly in your noble pact, and now
You're far away from home.

Think of an island, far away (Kokovoko!),
Lavished with splendors of a bygone day (Kokovoko!).
Someday, you will leave the Christians,
And make it to your island again, but now
You're far away from home!

Oooh, Kokovoko!

CALL ME ISHMAEL ➢ *Patrick Shea*

CHAPTER 65
The Whale as a Dish

Eat! Eat your delicacy,
Gourmand, eat the best-tasting things.
I'll teach you now (I'll teach you right now!),
How to love (The brains of a cow!):

Step one, break the head of a calf;
Step two, mix the flour by half;
Cook it up (I'm already salivating!),
And eat it up (Your mind is so stimulating!).

But the whale is a curious thing!
To big to be appetizing!
So barbecue up for the king, a porpoise tonight!
A porpoise tonight!

Baby, what you doin' here in this meat-market,
Being eyed up and down by every cannibal in town?
Find someone that will treat you right—
Come with me, and I'll teach you how to eat!

Step one, nail a duck to the floor;
Step two, feed it fat more and more;
The liver bloats (I'm already salivating!);
Thus, I emote (Your flavor is devastating!).

But the whale is a curious thing!
To big to be appetizing!
So barbecue up for the king, a porpoise tonight!
But don't eat by it's light,
No, not tonight!

CHAPTER 15
Chowder

Hold, my friend, lest the chowder relent!
Call to the kitchen for another bowl of this remedy
For pessimism!

I saw the world with an ominous bent,
Until such time as my gullet could vent the sweet relief,
This precious steaming.

Arrived today with a curious sway—
Nantucket does boast of The Try-Pots, with it's savory brine
Bubbling all the time.

But what sweet things at the gallows of hell,
To lift my soul from its habit of feeling all delights
With fearful leanings.

The sweetest clams you've ever tasted in your life,
Touched with salt-pork in a butterly broth of paradise!

I count myself in a fortunate bed,
Touched in the stomach but not in the head, to pleasantly
Await the morrow.

The landlady asked what to put in my dish
To break my fast, with the heartiest wish to satisfy,
I'm doubly now enticed.

The sweetest clams you've ever tasted in your life,
Touched with salt-pork in a butterly broth of paradise!

CALL ME ISHMAEL ➤ *Patrick Shea*

CHAPTER 61
Stubb Kills a Whale

La, la, la.
La, la, la.

Seen a squid 'bout a million times,
The spermaceti ain't far behind.

Drift along in a placid sea,
Slumbering in fraternity.

Lounging up to the surface, tan,
Calm, in sync with the hearts of man,

But how quickly those hearts can change
With a dollar in killing range.

Everybody could feel it—
Hushed encounters, anon.
Everybody could feel it.

Nonchalantly, we glide in chase,
Holding back to his languorous pace.
Anybody could see us, now,
Coming closer.

Suddenly, with a casual surge,
The flukes went high and the whale submerged.

Stubb replied with a pensive smoke,
A plain disguise for the lust awoke.

Everybody could feel it—
Hushed encounters, anon.
Everybody could feel it.

With a cry from the savage race,
Oars in furious, pounding chase.
Blood reflected on each man's face, now,
Coming closer.

Now a flurry, a punctured heart,
A calm again from the killer's dart.

There he scatters the ashes thin,
Where the wonders of life had been.

> La, la, la.
> La, la, la.

CALL ME ISHMAEL ➤ *Patrick Shea*

Afterword to Volume VI

As I discussed in an earlier afterword, throughout the *Call Me Ishmael* project, I used various musical or lyrical conventions, including genre, to comment on *Moby-Dick*. Not far into the project, I naturally started to use *Moby-Dick* to comment in turn on various musical or lyrical conventions. A great example of this kind of commentary appears in songs like "The Needle," "Enter Ahab; to him, Stubb," "The Sphynx," and "The Forge," among others. These songs frame Ahab's relationship with *Moby-Dick* as love songs, and required a startlingly little amount of finagling on my part in order to do so. Beyond having some affectionate fun with a book I greatly admire, the point of doing this was not so much to suggest that Ahab's true feelings for *Moby-Dick* are romantic, as to notice that many (or most) love songs embody unnervingly unhealthy relationships.

You would be hard pressed to find a love song about the daily joys of a happy and healthy marriage, though I can assure you the joys are many and worthy. The thing of it is, as with all good stories, pop songs need a certain amount of tension in order to be compelling. Since part of the joy of happy and functional romantic relationships is the lack of any serious strife, those relationships make for poor pop songs. What we do find compelling are songs about torment ("Tears On My Pillow"), or abuse ("The Beatles' "Run For Your Life"), or general dysfunction (the entire Magnetic Fields catalogue)—Ahab, Ahab, Ahab. The next time you encounter a love song, think of the singer as Ahab, and see how well it works.

To be fair and thorough, there is another prominent category of love song to recognize: the Al Green, Barry White, Teddy Pendergrass seduction. These songs seem romantic on the surface, but ultimately are so fixated on the physical parts of romance that they become humorously gross self-satire. I'm sure it happens to other people all the time, but I can't really imagine being seduced by one of these songs—they make me laugh too much. I had fun writing a food version of a seduction song with "The Whale as a Dish," ruining the appeal of delicious foods like foie gras with nasty enticements, in the same way that Barry White would, in the moment, ruin sex for me.

To be clear, these choices are affectionate on my part, and are meant to notice something about the things that appeal to human nature, rather than to disparage those things. In my opinion, there are few things in the world as great as a good love song. But still, I will leave with a challenge to the songwriters among us: try to write a sincere love song about a healthy relationship, and please email me when you do.

CALL ME ISHMAEL

VOLUME VII

CALL ME ISHMAEL > *Patrick Shea*

CHAPTER 49
The Hyena

In the worst of times,
When every angle aligns
To create the last ordeal,

Take the joke,
A great, affectionate poke
From the cosmos to a great contender.

Oh, you row, row, row,
To speed your slow,
Sufficient death.

Now a sailor's will
And testament do appear
As a way to while to time,

But the prudent sot
Finds humor yet in his lot,
And by sot I mean the great enchanted
Masses of mankind who manage,

Oh!, to row, row, row,
And ho, ho, ho,
To laugh and jest.

CHAPTER 125
The Log and Line

Log and line
Hanging from the outside railing,
Idly warped by elemental ability,
Exposure, stability.
And sometime heaved into the open ocean,
Held by rotten line
And towed behind the rush of ceaseless time.

Life-line, life-line!
Keep your grip on me,
Until my captain reels me in
To be mended.

Life-line, life line!
How could you succeed?
Nothing left so torn could hope
To be mended.

High and low,
Daft with strength and daft with weakness,
Coupled yet by sweetness,
And never rent—
No such strength is heaven-sent!—
It lives beyond our briefness.

CALL ME ISHMAEL ≻ *Patrick Shea*

CHAPTER 83
Jonah Historically Regarded

Everybody knows Jonah,
The whale, and its use,
As they used to know Hercules,
And the trials sent by Zeus,

But do we have to believe it?
It speaks to the soul
With impossible fantasy—
The facts aren't the goal.

(Don't confuse the two!)
History and story,
One tells no lies
And the other is written not to be boring,
To shock and surprise, oh!

History and story,
Both tell a tale
To communicate truths of life to our quarry,
To lift mystery's veil.

CHAPTER 82
The Honor and Glory of Whaling

We're a fraternity,
And the last common-beautiful in a long line
Who trace paternity
To the regal and dutiful, both alike

In their dominance
Over nature's providence!

Now take the Greeks—
They had offered Andromeda to appease
A great leviathan,
But then Perseus did slay it to save her life,

And they sang, "All ye virgins of the Mediterranean Sea,
Raise your bosoms to the future you'll get to be!"

We're a fraternity,
Even Jonah and Hercules do comprise
We captains of decease,
Though their victory was endurance, it's still a fight.

And Vishnoo; god of all creation, social elite;
Heads our roster with a fluke in place of his feet!

And we sing, "Na na na na na na na, na na na na na,
Na na na na na na na, na na na na na!"

CALL ME ISHMAEL ➢ *Patrick Shea*

CHAPTER 108
Ahab and the Carpenter

He's the unsung jester,
He presides with sniff and sneeze.
He's a bullshit tester,
He's a flutter up in the eaves.

With a hem and haw
Pointed high and low—
Nothing tests your wits
Like a man who's slow,

And Ahab stares into the great, unknown expanse,
A litmus shifting with the man's unknowing plans.

CHAPTER 107
The Carpenter

You take a man alone,
And he's an island of soul;
You take them all at once
And what's the difference?

Well, every man alive
Thinks he's an island of soul,
But every man alive
Is just a duplicate:

One wants an ear drilled,
One wants a birdcage,
Stubb wants stars on every oar!

But this equation of man
Comes out to negative one,
And it's the carpenter's soul
That makes the difference:

Come for an ear drilled,
Come for a birdcage,
He'll paint stars on every oar!

He's the difference,
Difference;
He's the difference.

Well he's a man at odds,
He's every interest,
And as he fills the needs
He stands indifferent.

There's not a man alive
Who stands indifferent,
But he's a man we prize
To be indifferent.

CALL ME ISHMAEL ➢ *Patrick Shea*

Come for an ear drilled,
Come for a bird cage,
He'll paint stars on every oar!

He's indifferent,
Different;
He's indifferent.

CHAPTER 120
The Deck towards the End of the First Night Watch

When the going gets tough,
The tough get going!
You see, the winds are getting rough
With no signs of slowing.
Just like a steeple on a bluff
Feels the worst of the blowing,
So the loftiest truck feels the worst of adversity.

Malady weighs for the rest of my days,
But I know the tempest will push me through.
Lift every sail, the worst we can fail
Is Hallelujah! Hallelujah!

CALL ME ISHMAEL > *Patrick Shea*

CHAPTER 131
The Pequod meets the Delight

It was a wind-blown summer's day,
Time was passing like an open book in the breeze,
Colors bled out into the nothing new,
Then we passed her in her grievance.

All eyes turned to the shattered boat,
Splintered planks as sun-bleached corpse,
Then a hammock sown into a sheath
Around a lifeless memory.

And Ahab trumpets for catastrophe,
And strikes his purpose into their misery.
The ship cries out for resurrection, now,
But death comes first, and then a sea of tears.

There hangs a coffin on the taffrail,
For all to see as we speed away
Into his everlasting promises.
The coffin waits to save a solitary soul.

CHAPTER 19
The Prophet

Well, you talk about a soul deficiency,
And you wax about a man who's come undone,
And you speak in opposition, then before our very eyes
Say so long and hallelujah, better him and he than me.

And it's easy! It's so easy
To make it seem the secret's inside of you.

You're a plot device; you speak in pronouns,
And disfigurement suggests the same within.
Did you strike into the darkness and escape a different man,
Or are you just a reference to an older way of writing books?

And it's easy! It's so easy
To make it seem the secret's inside of you.

CALL ME ISHMAEL ➤ *Patrick Shea*

CHAPTER 103
Measurement of the Whale's Skeleton

A yard, a yard, a yard,
Down to the smallest marble.
And all you grasping at the truth
Should honor the proof
Of greatness tapered
To the trivial and minute.

A fluke, a fluke, a fluke,
Down to an utter nothing.
The graceful tiller of the seas
Is lost to the breeze!
The spark of animation gone,
Obscuring the form.

Measure and catalogue remains,
But don't call the sum of all a whale—
The sum will surely fail!

A life, a life, a life,
Down to the fossil record.
As all you searching for the stars
Do not look to cars.
Though each cold skeleton exploded
Out from their hearts.

CHAPTER 79
The Prairie

Now read the face,
See everything placed—
Rest assured,
Once inured
No doubt you will meet
Nobility steeped
In each corner, all around.

From prairie there rose
No sign of a nose,
But it's fine,
We don't mind.
It's simple and sleek,
And no one can tweak—
Even kings can't boast the same.

And oh, take note!
And oh, it's plain!
And oh, the world bespoke
In his visage just the same.

Now look at the brow,
Could heaven allow
Such a mind
Laid behind?
It's not that he writes
Or speaks to our plights,
It's the genius of his life.

CALL ME ISHMAEL ➤ *Patrick Shea*

CHAPTER 70
The Sphynx

The deadliest calm,
A song indivisible
By the lonely.
Here is a man,
All alone. Oh!

The stillness of hearts,
We know as analogy
Drawn to nature.
Here is the sea,
Old and worn. Oh!

But love, ever blessed, is only known
Yet in our hearts!
Yet in our hearts!

The breeze of your touch,
A life to the miserable,
An elation.
Move me an inch,
Then a mile. Oh!

CHAPTER 69
The Funeral

Tick-tock,
Massive life to chalk,
And all foul inclinations rise.
The proof of a total disregard
In intemperate scavenging.

Think here
Of a death to fear,
As all grand intellection sums
To a nothing, to a phantom, a disgrace
To those remembering.

Umbrella sky
In the purview of Venus,
But out of the sky
Only frenzy and rape,
Not by design or divinity,
Only by absence of mind.

By chance,
Every touch and glance
Dissolves, but not all agency relies
On existence; your specter lingers on
With false alacrity,

To scare our savagery.

CALL ME ISHMAEL ➤ *Patrick Shea*

CHAPTER 86
The Tail

Fishes and worms wriggle at my feet,
Never the whale, oh no!,
His body won't allow a gesture meek—
And wriggling means you're weak!
Wriggling means you're weak!

Think of the greatest forms of beauty that we seek,
Marbles of demigods—
Hercules, shaped to the last oblique!
Strength and beauty meet!
Strength and beauty meet!

And, hey, what's the difference?
With no lost significance,
You turn the implications meant
Into the world's disease.
And its betterment?
Your social ease.

God in the Sistine seems a Minotaur of Crete
Next the Christ, his son,
Always painted just a tad effete—
The beauty's in His speech!
The beauty's in His speech!

So take a cue, my child, watching from your seat,
Letting the world sink in
Before you stand to act or stand to preach—
Wriggling means you're weak!
Wriggling means you're weak!

CHAPTER 62
The Dart

It's the harpooneer that makes the voyage strong.
It's the harpooneer that makes the voyage strong.
He needs to dart that iron hard and often long.

You give that kid the job of superman.
You row him 'til his feet can barely stand,
Then expect a dart with strong and steady hand.

And we sing it:

All along we're wishin'
For the worthy manumission
Of the working slave that leads our long parade!

Give an idle song to the man in the corner.
Give an idle song, 'cause his corner does lead,
And his work will come when we create the need,
But the dart will miss if you work him like a steed.

And we sing it:

All along we're wishin'
For the worthy manumission
Of the working slave that lead our long parade!

CALL ME ISHMAEL > *Patrick Shea*

CHAPTER 94
A Squeeze of the Hand

When a week of typhoons goes to your head
And brings you down,
When a reckless blood-quest wakes you in bed
And brings you down,
Never fear,
We got a tub of the right stuff!
Never fear,
Squeeze all the lumps from the white stuff!
Never fear,
It's silky-smooth and the smell
Will take your mind away!

Squeeze the sperm!
And lose the reason!
Squeeze the sperm!
And feel the feeling!
Squeeze the sperm!
And let your worries slip away!

When your cabin-boy goes soft in the head
And brings you down,
When your best friend almost dies in his bed
And brings you down,
Never fear,
We got a tub of the right stuff!
Never fear,
Squeeze all the lumps from the white stuff!
Never fear,
It's silky-smooth and the smell
Will take your mind away!

Squeeze the sperm!
And lose the reason!
Squeeze the sperm!
And feel the feeling!
Squeeze the sperm!
And let your worries slip away!

Afterword to Volume VII

I'm certainly not the first person to read a novel as one would read the Bible—out of order, one chapter at a time—or to find that *Moby-Dick* lends itself particularly well for the purpose. But since this project demanded that approach, I think it's worth discussing. People often talk about how they don't like the "middle part" of *Moby-Dick*, or find it boring, because the story disappears almost entirely. The story that these people are missing in the middle of the book is the Ahab story, and yes, it almost entirely does disappear. However, these chapters are definitely not extraneous—*Moby-Dick* would not be *Moby-Dick* without them. For me, the way to reconcile the necessity of these chapters with the seeming disappearance of story is to acknowledge that the Ahab story isn't really the main story of the book. For me, the story of *Moby-Dick* is the story of Ishmael learning how to use his role as outsider to tell a good story, and in so doing, to find a social purpose to connect him with community. Ishmael's experiences with Ahab make for a good plot with which to frame this growth, and to give it direction as any good storyteller would, but for me the middle chapters are really the meat of the story. In these chapters, Ishmael studies the world around him and reflects on the greater implications of what he sees. He also experiments with various styles of storytelling, and in the end becomes the survivor who writes the history. Reading the chapters of *Moby-Dick* out of order over the course of many years really helped to free me from craving plot and direction, and helped me to focus on that much more abstract and non-linear story of Ishmael that ties the book together as a whole.

The reflective nature of each chapter, particularly those middle chapters, is what makes *Moby-Dick* such a good *Bible*. There are chapters with obvious wisdom or solace to offer. When I feel like nothing's going right, and the world is out to get me, I read "The Hyena," and remember to laugh about things when they're at their worst. When I'm worn down by work, and feel like I haven't had a moment of rest in weeks, "Stowing Down and Clearing Up" shouts, "Oh! My friends, but this is man-killing! Yet this is life," and I buck up a little. And when I find myself generally let down by humanity for whatever reason, and I feel like an outsider myself, "Loomings" and "The Carpet Bag" help me remember that these feelings aren't original to say the least, which affords me a little bit of perspective on whatever happens to be bothering me.

The focus and pace of this project only heightened this approach of seeking life's answers in the pages of *Moby-Dick*, especially in the course of writing the weekly blog posts to present each song. I often felt like a priest preparing a sermon each week, as I read and reread a new chapter, and thought about what it means to me, and what insight it might offer to other readers about the world at large. Invariably, the events and thoughts of my week shaped my reflections on the book, and invariably the events and thoughts of the book shaped my reflections on my daily life. I'm sure if I wrote each blog post again, I would have totally different things to say about some of the chapters than I did when I originally wrote each post.

I like the idea of books and people interacting with each other, and informing each other's conceptions of the world at large. The interaction is an intimate one, and as with any

CALL ME ISHMAEL ➤ *Patrick Shea*

relationship, you really have to find the right book to make the interaction fruitful. There's something about *Moby-Dick* that really helps me find my center, and in that respect, this project was a foregone conclusion from the moment I opened up to reading that first iconic sentence, and everything that follows.

CALL ME ISHMAEL

VOLUME VIII

CALL ME ISHMAEL ➤ *Patrick Shea*

CHAPTER 51
The Spirit-Spout

How now, Fedallah, you give us a fright
Up on the mast-head at night—
If you're searching for misery,
You'll find it alright.

Seen in the moonlight a silvery spout,
And followed, we utter devout—
Entranced by our misery
And beckoned without.

All in good time you'll realize
That everything's white in the moonlight;
It's a trick of the night.

Birds beat the black air, relentlessly fleet;
Fish leap in tormented sea—
Trapped by their misery
And condemned to repeat.

Promise, exalted from deepest despair,
What else a fountain so fair?—
It's only our misery
Finally laid bare.

All in good time you'll realize
That everything's white in the moonlight;
It's a trick of the night.

CHAPTER 121
Midnight—The Forecastle Bulwarks

>I take a turn on the floor
>To lash the anchors once more.
>I don a gentleman's hat
>And the coattails to match
>'Cause they channel the storm.
>
>And so I keep myself dry
>But when the lightning comes by
>It don't give me no pause
>'Cause I've counted those odds
>Like a sensible man.
>
>And my flesh ain't the same as yesterday;
>My mind's the same,
>It never stays in the place I started from.
>
>I'm a sensible man.
>I'm a sensible man.
>I see the cards in my hand,
>And play them out as I can.

CALL ME ISHMAEL ➤ *Patrick Shea*

CHAPTER 80
The Nut

The phrenologist says, "You're gonna have to wait for a while—
The skull of this whale is buried twenty feet from its smile."

And I say, "Woe to the sailor; cheers to a stunning conceit—
So human is the notion that the head is the spiritual seat."

And you say, "Maybe in a monster renowned more for power than guile,
The ghost in the machine lives in the high Roman forehead with style."

And I say, "With every minute, the character that's in it must rest
Upon a mighty flagpole—the backbone's the answer to test."

Its vertebrae, close to the spigot
Equal the source in size, to the digit—
There resides a will, inflexible by its very design.

The phrenologist says, "You're gonna have to wait for a while—
The skull of this whale is buried twenty feet from its smile."

CHAPTER 66
The Shark Massacre

'Round and 'round, neither up nor down,
The teeth of sharks till a fertile ground.
An empty eye, a cold machine
Bites in reflexivity.

A giant whale, a mass deceived,
After sharks visit for a meal,
And strip each bone, and leave no meat—
Quite a thorough industry.

And even cut, a shark will eat
The entrails out of its own defeat,
And once consumed, the entrails leak
Back out of its misery.

Beware, young man, for death misleads,
A soulless shark still pursues its greed.
It snaps its jaws when thus subdued,
Pain fulfills it more than food.

CALL ME ISHMAEL > *Patrick Shea*

CHAPTER 109
Ahab and Starbuck in the Cabin

Leaky casks
In the autumn of my voyage,
Never checked.
Leaky casks
In the hold of leaky vessel,
On and on.

Leaky casks
Lose in double-time what's gathered
Tooth and nail,
And the ordinary thoughts we carry sink
In the sea.

When the sea fills the vacuum left behind,
Then the mind will come to weigh,
And the spirit loses buoyancy.

Leaky casks,
Never thought I'd stop to fix them,
By and by,
But convincing me, my enemies are kind
Yet to me.

When the sea fills the vacuum left behind,
Then the mind will come to weigh,
And the spirit loses buoyancy.

Leaky casks
In the autumn of my voyage,
Never checked.
And the ordinary thoughts we carry sink
In the sea.

CHAPTER 126
The Life-Buoy

Now off we sail to the cursed hunting grounds,
Accompanied by the most unearthly sounds—
Baby seals, lost and found,
And their mothers searching 'round.

The first event in the dark preceding dawn,
A sudden death to the first advancing pawn.
Sunken men tell no tale,
And the life-buoy did fail.

And oh!, hide your look;
The day-to-day often took your breath,
But no shudder shook
From abstractions of this book.

He tells the mate to replace the buoy lost
And though the mate knows that death is never crossed
And survived, never-mind,
Make that coffin float in kind.

And oh!, hide your look;
The day-to-day often took your breath
But no shudder shook
From abstractions of this book.

The carpenter is a forward-facing man;
He sees the task as a step-by-step demand.
Starbuck balks, the details bore,
And he ponders God once more.

And oh!, hide your look;
The day-to-day often took your breath
But no shudder shook
From abstractions of this book.

CALL ME ISHMAEL ➤ *Patrick Shea*

CHAPTER 114
The Gilder

Narrator:
On and on,
The great golden sun
Gilds the vales and the hills like the heavens.

And on and on,
The sea rolls anon,
How the grass in fields dip and leaven!

Ahab:
But 'round and around and around,
Our fortunes come tumbling down,
Then raise to the peak of a crown,
Like the sea.

As cold is decayed from the warm,
The blessings come crossed by a storm,
And orphan our floundering forms
In the sea.

Ahab's men:
Oh, give us a captain of woe
And we'll row and we'll row and we'll row,
And we'll face a magnificent foe
Such as He!

Starbuck and Stubb:
The sea coaxes me
To always believe
In the meadows
Of my old-fashioned home,
Like the gelding
Stretched in full gallop on.

CHAPTER 105
Does the Whale's Magnitude Diminish?—We He Perish?

Relentlessly
Across the sea,
We hunt the whale for eternity.
As we revile,
For guts and guile,
The whale will never disappear.

How now, Pliny, you imply diminishment
In fanciful data of yore.
The whale at present has grown with significance;
You misjudged greatly before.

Relentlessly
Across the sea,
We hunt the whale for eternity.
As we revile,
For guts and guile,
The whale will never disappear.

How now, landsman, you argue extensively
The whale will perish in full,
Just like bison, that man did exterminate
Down to the very last bull.

Relentlessly
Across the sea,
We hunt the whale for eternity.
As we revile,
For guts and guile,
The whale will never disappear.

We are whalemen, and as such infallible
In all cetacious regards,
And nothing truer bespoke we with amity:
Extinction's not in the cards!

Extinction's not in the cards!

CALL ME ISHMAEL > *Patrick Shea*

CHAPTER 115
The Pequod meets the Bachelor

Hooray!

Well, we're on our way
Homeward! Cheer us on our victory day.

We're on our way,
Set the honest work aside for honest play.

Hooray!

Every cask is full, and then some—
The hold is overflowing!

Hard times for you?
We're sorry; we spoke not even knowing!

Hooray!

Ahab:
Thou art too damned jolly.
Head thee home if home is calling.
Get thee on your way—
That's all I really have to say.
Get thee on your way,
Hey, hey, hey.

Hooray!

When we're flush, we're flush—
Hop aboard; we'll treat you to a party.

White whale what?
Lighten up; you think you're such a smarty.

Well, we're on our way
Homeward! Cheer us on our victory day.
(Thou art too damned jolly.)

Well, we're on our way
Homeward! Cheer us on our victory day.
(Get thee home if home is calling.
Get thee on your way.)

Hooray!

CALL ME ISHMAEL ➤ *Patrick Shea*

CHAPTER 50
Ahab's Boat and Crew—Fedallah

Stand in the boat with a new leg.
Knee in the cleat, it's a new day.
Lift up the lance, make it bloody,
All on one, not two legs.

And all men with two legs are but a hobbling wight
When thrown deep into the tangle of a dangerous fight.

Cover the deck with a new sheath.
Walking erect, would you believe?
He points at the whale as a brute thief
But never asks no relief.

And nobody's gonna give this Captain Ahab a boat,
So he finances the crew that's gonna keep him afloat.

Wouldn't you know, heading the crew
Is the devil's due?
Wouldn't you know, dim as the dusk,
He's the devil's tusk?
Wouldn't you know, fevered in dreams
See we phantom things?
Wouldn't you know?
Wouldn't you know?

CHAPTER 84
Pitchpoling

How I love my daily grind.
How I love my daily grind.
Daily grind!

Whales that flee in agony,
Desperately, to seek relief
That they won't find.

Stretching taut a lengthy line,
Out of reach but fixed in mind—
What a bind!

So I'll pitchpole my way (Wait to see it!),
Pitchpole my way (You won't believe it!),
Pitchpole my way, and kill me a whale—
He'll suffer, hey, hey!

Staying out beyond the lance,
Whaley thinks he has a chance,
But there's no chance!

Tossing out my sharpened love,
Death will reach him from above—
We'll drink his blood.

And, I'll pitchpole my way (Wait to see it!),
Pitchpole my way (You won't believe it!),
Pitchpole my way, and kill me a whale—
He'll suffer, hey, hey!

How I love my daily grind.
How I love my daily grind.
Daily grind!

CALL ME ISHMAEL ➤ *Patrick Shea*

CHAPTER 72
The Monkey-rope

Cannibals, cutting spades, sharks snapping free,
All tossed in the sea
With Queequeg and me.

Great consternation aloft and between,
Begun at the scene
And taken to mean

That islands exist only in our dreams,
Not reality,
And Fate can't prevent a slip.

Think it insurance; the danger is spread
To many a head,
And thus was I wed.

A monkey-rope fashioned and tied to my belt,
And tied to his belt,
Security felt

By none and by all simultaneously,
Bonded famously.
We feel one another's slips.

Stubb instituted this perilous plot
To rally our lot,
Though moral or not,

Just as Aunt Charity's temperance would do,
Encouraging through
Restrictive milieu.

But false institutions never lent
To our betterment.
We're tied by the bonds of men
To defend
The one at the risk of ten.

CHAPTER 20
All Astir

Think of the things a housekeeper brings to have, oh yeah!
Each item needed, nothing conceded, yeah?, oh yeah!

Think of the patience
For careful creations,
Of pantries that never fail.

Aunt Charity!
Aunt Charity, oh yeah!

Think of the volume of stores used in three years' time, oh yeah!
Bother and beans, a housekeeper seems a bore no more!

Think and be thankful
Of each sturdy ankle,
That make wishes never want.

Aunt Charity!
Aunt Charity, oh yeah!

Charity's bounty
Could cover the county—
Everything far and wide!

Aunt Charity!
Aunt Charity, oh yeah!

CALL ME ISHMAEL > *Patrick Shea*

Epilogue

Now but clipped of wing,
I circle 'round an empty scene
As if cradled in descent
By solitude.

Dirge of wandering,
Buoyed by a lost belief,
Irrevocable as all
Eternal vows.

Always a peace that lives between the punished
And the punisher, therein lies the defeat.

In the desert marked,
A signal to the world of sharks
That a punished man must live
To tell the tale.

Oh, the many morbid things
That the Fates obliquely sing
To the poets
Through a man come tumbling down.

You can call me Ishmael,
May the muse speak through me well,
As I sing to you
The world's most principle song.

And how
He
Looms in the middle of it all
Spectacularly.

Afterword to Volume 8

Moby-Dick boasts not only one of literature's great beginnings, but also one of literature's great endings. After Ishmael is thrown clear of Ahab's boat in the final chase, Ishmael floats far enough on the periphery (figuratively perhaps, as well as literally) to live to tell the tale. As he escapes the all-consuming vortex created by the Pequod as it sinks, the vortex offers back to Ishmael a means of survival—his bosom friend Quequeg's coffin—which Ishmael uses to stay afloat until rescued by another ship. Meanwhile, the sharks and sea-hawks leave Ishmael unharmed, and if we didn't know better by now, we might be led to think that Ishmael has been marked like a Cain to wander unmolested, telling the Pequod's tale. Either way, at the end of *Moby-Dick*, Ishmael the storyteller sits poised at the beginning of his tale.

In "The Life-Buoy," the Pequod's carpenter objects to his ordered task of turning Quequeg's unneeded coffin into a new life-buoy for the ship, saying:

I like to take in hand none but clean, virgin, fair-and-square mathematical jobs, something that regularly begins at the beginning, and is at the middle when mid-way, and comes to an end at the conclusion; not a cobbler's job, that's at an end in the middle, and at the beginning at the end.

I can't help but think that Melville's talking about his own book with these words from the carpenter, because I couldn't describe *Moby-Dick* any differently than that. Many of the chapters in *Moby-Dick* feel as if Ishmael is narrating his story in the moment, as the story unfolds. Some chapters feel more like a journal, reflecting on events recently transpired. In "The Town-Ho's Story," we find Ishmael telling his tale in a South American bar somewhere in the future. The "Epilogue" similarly implies that Ishmael's story could only begin with Ishmael's survival of Ahab's quest. Though by all means fully cohesive, the book as a whole feels cobbled together from the perspectives of various moments in time.

This feeling of drifting perspectives for me implies a bigger idea of story as a living, breathing, social being, evolving over time; and of the storyteller as less a keeper of historical record, than as a curator, finding prescient thoughts about the present in his ongoing cobbling of things past. This kind of caretaking is also exactly what each of us readers does when reading and discussing literature, and what each of us human beings does when living through the events of our lives. We participate in our present and future by examining and sharing the things that we learn and experience.

In no way do I think that *Moby-Dick* leaves us with a moral, but I do wonder if we're supposed to take something away from Ishmael's lone salvation. The vortex of Ahab's madness spares only Ishmael, a man who never took sides, who stood so far aloof from his world and his people that he remains untouched by the things he nonetheless observed. In the end, all that the vortex offers back to Ishmael is the memory of his dead friend to buoy him further along, unmolested but alone. Ishmael found a home in Quequeg and the Pequod's crew, but never fully engages with that home, and so finds himself in the end an orphan, wandering the world, and not to make the same mistake twice, telling a very important story—a story about the essential human need for story.

CALL ME ISHMAEL ➤ *Patrick Shea*

About the author

Patrick is an elementary school teacher and a musician in New York City. He has been an active songwriter and musician since his high school days in Portland, Oregon. He also likes to spend time with his family, as well as read; run; and learn about music, history, science, and electronic circuits. Patrick lives in Brooklyn, New York with his wife and daughter.

Visit Patrick's blog at: http://callmeishmael.org

www.ingramcontent.com/pod-product-compliance
Lightning Source LLC
Chambersburg PA
CBHW032014170526
45157CB00002B/689